IMAGES
of America

WEST PALM BEACH
1893 to 1950

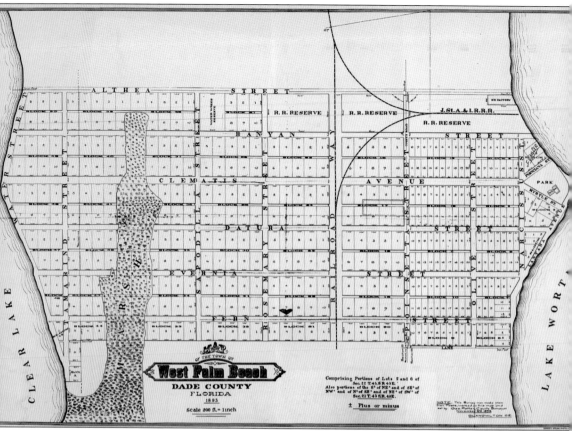

This 1893 map of West Palm Beach, Florida, by George W. Potter, county surveyor, illustrates Henry Flagler's desire to create a beautiful entrance to his island paradise of Palm Beach. The town was designed to be a residential and commercial center for his employees who were building and running the railroad, luxury hotels, and other independent businesses. This area is still the center of West Palm Beach.

ON THE COVER: In this photograph, taken May 20, 1885, pioneers inspect land believed to be located between Lake Worth and Clear Lake. From left to right, they are George W. Potter, Grace Lainhart, Ellen E. Potter in dark dress, Martha Lainhart in white dress, George W. Lainhart, Dr. Richard B. Potter, Hiram F. Hammon, and William M. Lanehart. Despite spelling their surname differently, William Lanehart and George Lainhart were brothers. Hammon received title to the area's first homestead claim of 169.2 acres on August 25, 1882, and eventually sold it for $1 million, a real estate record at that time. Richard Potter was the first physician to live on Lake Worth. His sister, Ellen, and their mother, Lydia, bought adjoining properties that extended from Lake Worth to Clear Lake. Ellen later donated five acres and sold five acres of her property to the school board to build a school on the hill west of the downtown area overlooking Clear Lake.

IMAGES
of America

WEST PALM BEACH
1893 to 1950

Lynn Lasseter Drake and Richard A. Marconi
with the Historical Society of Palm Beach County

ARCADIA
PUBLISHING

Published by Arcadia Publishing
Charleston, South Carolina

Printed in the United States of America

Library of Congress Catalog Card Number: 2006922343

For all general information contact Arcadia Publishing at:
Telephone 843-853-2070
Fax 843-853-0044
E-mail sales@arcadiapublishing.com
For customer service and orders:
Toll-Free 1-888-313-2665

Visit us on the Internet at www.arcadiapublishing.com

*With many thanks we dedicate this book to
Diana Betancourt Marconi and Christopher Drake,
without whose love, support, understanding, and patience
this work would have been difficult to accomplish.*

CONTENTS

ACKNOWLEDGMENTS

We would like to thank the Historical Society of Palm Beach County for allowing us to use photographs from their collection of approximately two million images. A special thank you goes to Debi Murray, director of research and archives, for her extraordinary editing skills and keen eye during the writing of this book. We would also like to thank our editor at Arcadia Publishing, Adam Ferrell, for his patience, understanding, and direction.

Unless otherwise noted, all images are courtesy Historical Society of Palm Beach County.

INTRODUCTION

West Palm Beach was the brainchild of Henry M. Flagler, Florida railroad magnate and Standard Oil partner. Founded as a commercial and residential center to support Flagler's hotels, West Palm Beach rose from sandy scrub to become the leading metropolitan and governmental center for Palm Beach County. In 1894, it was much different. In fact, a resident described the town as "a stretch of the whitest of white sand, two steel rails, a few acres of pineapples, a couple of houses, and 'scrub' on every side!"

Henry Flagler visited the Lake Worth area in 1892 while scouting a route to extend his railroad south. He found a lush jungle paradise on the shores of Lake Worth where he envisioned a resort for wealthy northern visitors transported there by his railroad. The following year, he returned to build his resort. Flagler's plans set off a land boom that ended the pioneer era on Lake Worth.

Flagler bought land on Palm Beach to construct the first of his two hotels, the Royal Poinciana (1894) on the west side of the island, and in 1896, the Palm Beach Inn (later known as the Breakers Hotel) was built on the ocean side. With the influx of workers, Flagler looked across the lake to the mainland to establish a residential and commercial center to support the resort. With $45,000, he purchased the O. S. Porter and Louis Hillhouse properties, creating the nucleus of downtown West Palm Beach.

The area was laid out in the typical gridiron pattern of the day with the streets alphabetically named after plants common to the area. The town was only 48 blocks and stretched from Lake Worth on the east to Clear Lake on the west and from Althea (now Second Street) on the north to Fern Street on the south. The first lots were sold at auction on February 4, 1894, at the newly constructed, but not yet opened, Royal Poinciana Hotel.

At a meeting held at the "calaboose" (jail) on November 5, 1894, residents voted to incorporate as a municipality. Flagler provided much of the infrastructure for the fledgling town, including land and money for churches, public buildings, and fire equipment for the Flagler Alerts, the volunteer fire department.

By 1895, the town had grown to a population of more than 1,000 people. In the first months of 1896, two fires, just weeks apart, destroyed much of the business district. This resulted in a change to the building codes, and structures had to be built of stone, brick, or brick veneer. By the time the devastated area was rebuilt, West Palm Beach could boast well-maintained streets, hotels, churches, stores, a post office, a library, schools, a water and electric plant, sewer system, city dock, railroad station, and a bridge crossing Lake Worth to Palm Beach. By 1903, the town had grown large enough for the town council to ask the state legislature for permission to become a city.

The city continued to grow, and its fate was sealed when the state legislature passed Senate Bill Number 18 in April 1909, establishing Palm Beach County with West Palm Beach as the new county's seat of government. Despite the construction moratoriums created by World War I, the crown jewel of Palm Beach County and south Florida experienced a land boom that lasted into the 1920s. This pressure on the existing infrastructure caused a frenzy of construction just as the war ended. This in turn brought even more people seeking jobs to the land where "summer

spends the winter" to fulfill the need for workers and those who could supply the variety of goods and services that such growth requires.

New construction, including office buildings (and the city's first skyscrapers), hotels, hospitals, and housing subdivisions, proliferated. In 1917, the West Palm Beach Canal was completed, providing access to the farming areas of western Palm Beach County. This made the expanding city the main distribution center for the county's fruit and winter vegetables that were shipped throughout the United States. In 1925, a second railroad, the Seaboard Air Line Railway, arrived in the city, enhancing the long-distance transportation system. West Palm Beach became a popular tourist destination for the middle class.

The economic good times of the 1920s soon began to spiral out of control and quickly headed for a crash. During the boom, property values went up as investors and speculators bought and sold land (many times sight unseen) at alarming rates. In 1926, a terrible hurricane caused significant damage to south Florida that caused investors to lose confidence in Florida real estate. Northern newspapers and investors also began publicizing reports of unscrupulous real estate deals. When the Florida East Coast Railroad put a moratorium on shipping construction materials, building came to a halt. Local banks started to fail, which affected commercial and land investments. To top it all off, a second and even more damaging hurricane hit south Florida in 1928.

This second hurricane laid waste to most of Palm Beach County and killed at least 3,000 people. In the Glades area, the Lake Okeechobee dike failed, flooding the communities on the southeastern lakeshore. These factors contributed to the end of the south Florida land boom, causing the state to enter into a depression long before the rest of the United States did after the stock market crash of October 1929.

Property values dropped dramatically in West Palm Beach and elsewhere during the Great Depression. However, there still was some progress in the city during the 1930s. Palm Beach Junior College (today's Palm Beach Community College) was Florida's first junior college when it opened in 1933. The new county airport, Morrison Field (present-day Palm Beach International Airport) was dedicated in December 1936. It was named in honor of the late Grace Morrison, who had spearheaded the drive to establish it.

By the end of the 1930s, dark, forbidding clouds loomed on the horizon as Europe went to war. As the military began expanding, the U.S. War Department approved a plan to lease Morrison Field as an Army Air Corps base, and in 1942, the army established the Air Transport Command there. This brought thousands of servicemen to West Palm Beach. Other civilian facilities in the area were used to support the war effort and to entertain troops. When World War II ended, veterans who had trained or passed through Florida during the war fondly remembered the wonderful climate and returned as soon as they could for work, vacations, or retirement. This migration began a new era of development for West Palm Beach and neighboring communities that has continued into the 21st century.

West Palm Beach may have been the idea of one man, but it has been a variety of people from diverse backgrounds and their contributions that have made West Palm Beach one of south Florida's most desirable locations in which to live and visit. What follows is a pictorial journey through West Palm Beach's past. By illustrating the key people, special events, and other changes over time, we gain a better understanding of how West Palm Beach got here and where it is going.

Hope you enjoy the journey!

—Richard A. Marconi
June 28, 2006

One

PIONEERS OF
WEST PALM BEACH

In 1893, pioneer surveyor George Potter laid out West Palm Beach as the support center for Henry Flagler's Palm Beach resort. Up to that time, most settlement had been scattered along the east shore of Lake Worth, although a handful of people were living on the mainland. Those early settlers survived by farming, hunting, fishing, and scavenging goods from shipwrecks along the ocean. Items they could not grow, catch, or scavenge had to be shipped from Titusville; several families made their living by running steamers between there and Lake Worth. Despite the remoteness of the area, tourism had also been a thriving business since 1880. At that time, Elisha N. Dimick added rooms to his house and opened the Cocoanut Grove House, the first hotel, on the island of Palm Beach.

Flagler stepped up the tourist business several notches when he built the Royal Poinciana Hotel on Palm Beach and brought the Florida East Coast Railroad to West Palm Beach. This activity brought new people who opened businesses in the fledgling town. More people meant more amenities were needed, including churches, stores, restaurants, saloons, modest hotels, houses, and government. By the end of 1894, West Palm Beach had incorporated as a town—the first municipality in what would become Palm Beach County.

While Palm Beach maintained its status quo as a winter resort destination for the wealthy, it has been the residents of West Palm Beach that pushed their city ahead. It is due to their contributions that the city of West Palm Beach has become the leading metropolis in the county.

Henry Morrison Flagler, longtime partner of John D. Rockefeller, made his millions with Standard Oil Company. After Flagler retired, he came to Florida to build a railroad and hotel empire. The Florida East Coast Railroad arrived in West Palm Beach in 1894, and by 1912, it reached Key West, opening up the entire Florida east coast. Flagler died the following year in Palm Beach.

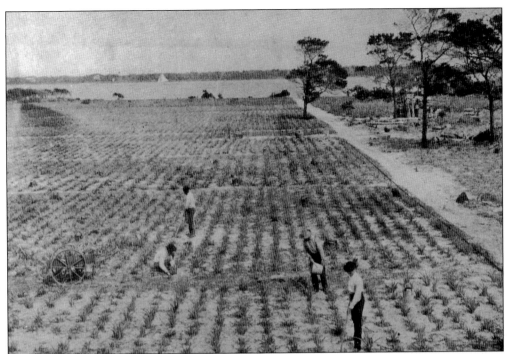

In the late 19th century, the pineapple industry was the number-one agricultural enterprise in southeast Florida. In 1892, Winfield Scott and Adella Clow of Pittsburgh purchased 49 acres centered on 7th Street from Louis Hillhouse for $2,450. Windella Plantation's name was a combination of Winfield and Adella's first names. Above workers are planting pineapples at Windella Plantation. Blight would eventually end Florida's pineapple industry in the early 20th century.

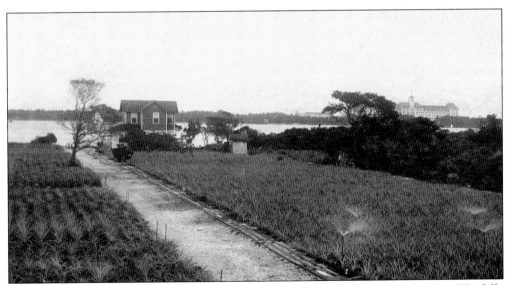

The Royal Poinciana Hotel on Palm Beach could be seen from the Clow residence at Windella Plantation. Clow erected an irrigation system on his plantation using water storage tanks powered by windmills, an innovation for the time. A brochure for Windella states that the company owned 100 acres, part of which was laid out for development and known as the Clow Addition.

Dr. Richard B. Potter, born in 1845 in Massachusetts, left Ohio in 1874 with his younger brother, George W. Potter, and moved south to Biscayne Bay in hopes of improving George's health. They farmed and harvested coontie to make starch. Richard served Dade County as a U.S. customs inspector and deputy U.S. marshal from 1875 to 1876, and in April 1877, he was appointed clerk of the circuit court. Learning there was a need for a doctor on Lake Worth, they moved in 1881. In 1893, Dr. Potter built a residence with an office on the lakefront near the foot of present Gardenia Street in West Palm Beach and made calls in his naptha launch, stopping to pick up Millie Gildersleeve, a midwife, when a birth was imminent. He died from complications of surgery in 1909 in Jacksonville, Florida.

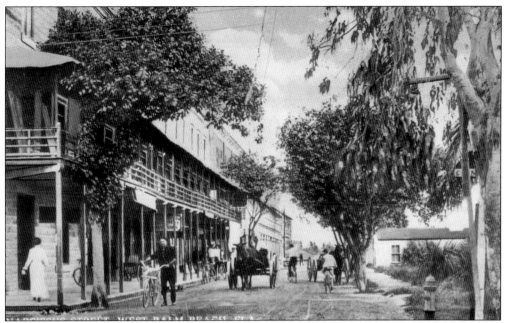

The first post office was opened in a tent on April 17, 1894, at the northwest corner of Narcissus and Clematis Streets. John Stowers, first postmaster, erected a two-story building on the site with the post office, grocery, and office space. The post office remained in the three-story brick Palms Hotel until 1915, when a new post office was built on the site of the Metcalf Building on North Olive Avenue.

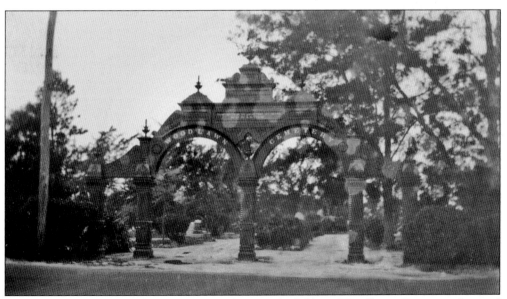

In 1904, Henry Flagler laid out 17 acres of pineapple fields as Woodlawn Cemetery. Located opposite Lakeside Cemetery on the west side of Dixie Highway, this ornamental iron gateway (shown here in December 1920) was erected by Flagler and was inscribed with bronze lettering: "That Which Is So Universal As Death Must Be A Blessing." Dixie Highway was widened in 1925, making it necessary to remove the gate.

West Palm Beach's first jail and police station, called the "calaboose," was located on the corner of Poinsettia, now Dixie Highway, and Clematis Streets. Local residents met "atop the calaboose" on November 5, 1894, to vote on the incorporation of the Town of West Palm Beach, and the motion passed 77-1. A new city jail was built at the corner of Rosemary and Banyan Streets in 1921.

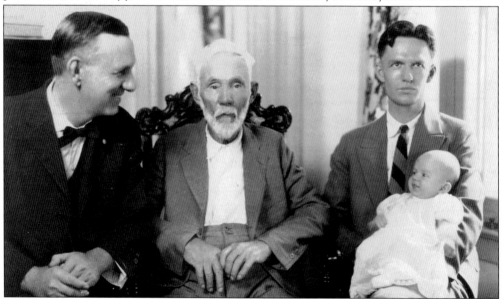

Four generations of the Earman family are shown from left to right: Joseph Lucien; the patriarch, John Sites; and John Burke with his son, John Robert. John Sites Earman was the first mayor of West Palm Beach, an office he held from 1894 to 1896. Originally from Virginia, Earman served as a scout in Stonewall Jackson's army during the Civil War and had quite the reputation as a wrestler.

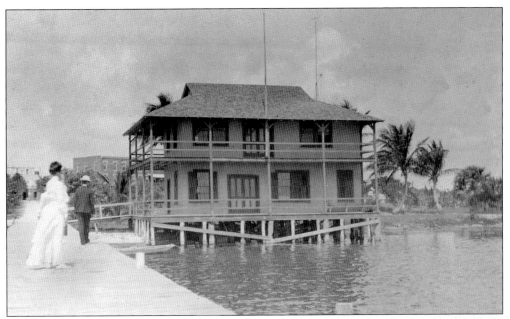

The building occupied by the Free Reading Room originally belonged to the Palm Beach Yacht Club in Palm Beach. Donated in 1895 by Commo. Charles John Clarke to West Palm Beach, it was delivered by barge to the foot of Clematis Street and converted into the first library. Local residents supplied the library with books and furniture to lure workers away from the saloons on Banyan Street.

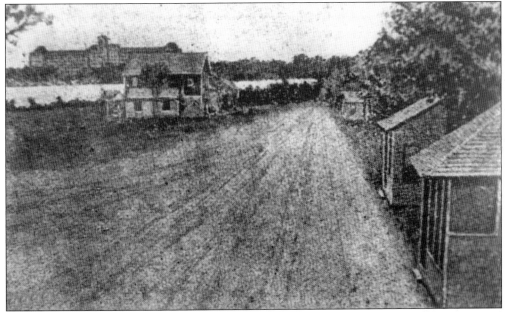

Looking southeast down Myrtle Street, now South Clematis, in 1895, one could see the Royal Poinciana Hotel on Palm Beach. Myrtle Street once ended at Lantana Avenue until the property on the west side of Lake Worth was filled in to build Flagler Drive along the waterfront. Flagler enterprises required many workers, and houses like the ones pictured on the right were built for these employees and their families.

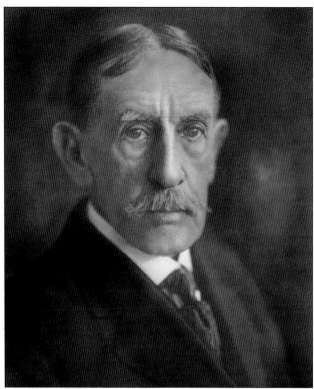

George W. Potter, born in 1851 in Massachusetts, gave up his job as a cartoonist for the *Cincinnati Enquirer* in 1874 to move to Florida with his brother, Richard. George, who suffered from asthma, regained his health and became the first surveyor in Dade County. In 1885, George and Capt. Owen S. Porter established the first real estate firm in Dade County.

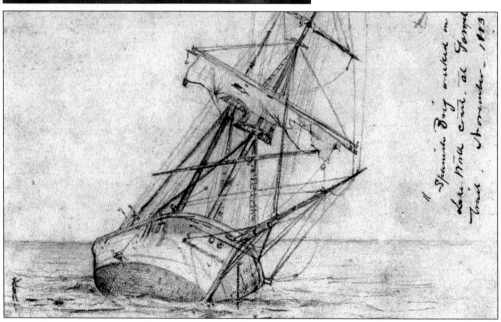

George Potter was a remarkable artist and sketched many scenes of south Florida pioneer life such as this wrecked Spanish brig. In 1893, George married Ella May Dimick, daughter of Frank and Anna Dimick. The same year, he partnered with George Lainhart to open Lainhart and Potter, a lumber company that supplied Flagler with building materials for the Royal Poinciana Hotel. George Potter died in 1924 and Ella in 1964.

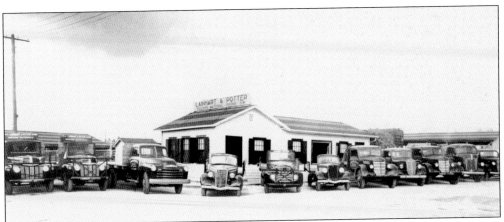

Pictured here in the 1920s, Lainhart and Potter Lumber Company is the oldest business still operating in West Palm Beach. George W. Lainhart and George W. Potter formed the company in 1893 and built their business through "square dealing." Customer service was first and foremost, as it remains today. Lainhart bought the interest of his partner, George W. Potter, shortly before Potter's death in 1924.

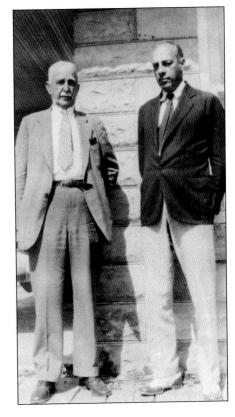

George W. Lainhart, born in 1849 in New York, is shown with his son, Spencer Toll Lainhart. In 1870, George and his brother William Lanehart lived in Titusville. George went back to New York in 1879 and, in 1884, returned with his family to Lake Worth. Four years later, he and George Potter started Lainhart and Potter, which supplied most of Flagler's building materials. George died in New York in 1930.

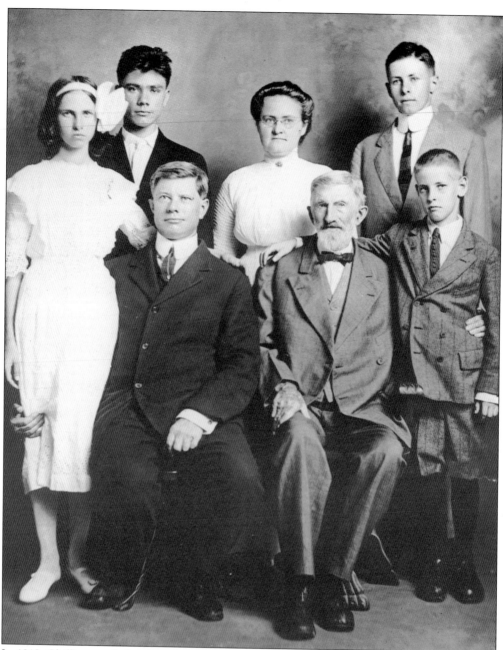

In 1913, Chillingworth family members are pictured from left to right: (seated) Charles C. and Richard Jolley; (standing) Marguerita, Walter, Jennie, Charles E., and Richard C. Chillingworth. Richard Jolley served as sheriff of Dade County from 1895 to 1901 and mayor of West Palm Beach from 1899 to 1901. His son, Charles C., was a lawyer with the firm of Robbins, Graham, and Chillingworth and served as the first West Palm Beach city attorney. His son, Curtis, served in the navy during World Wars I and II. After World War I, he joined his father's law practice, and at 26, he was the youngest elected circuit judge in Florida's history. Curtis and his wife, Marjorie, were abducted in 1955 by a corrupt West Palm Beach municipal judge who hired two men to abduct them, take them out to sea, and drown them. Their bodies were never found.

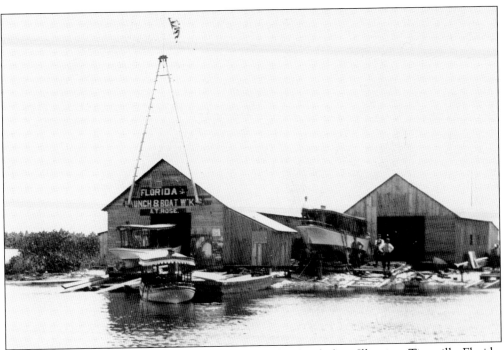

Anthony T. Rose (1857–1932), a boat builder, brought his family from Illinois to Titusville, Florida, in the early 1890s. In 1895, they relocated to West Palm Beach where Rose established the Florida Launch and Boat Works on a point on the western shore of Lake Worth, now Phillips Point. Rose could build or repair most types of boats.

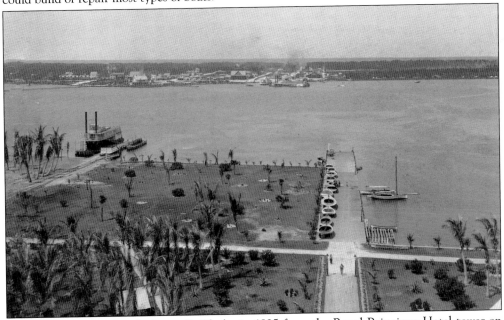

This photograph, taken by Louis S. Clarke in 1895 from the Royal Poinciana Hotel tower on Palm Beach, gives a bird's-eye view of Lake Worth and the fledgling town of West Palm Beach. Passengers were ferried from West Palm Beach to Palm Beach and back on steamboats like the one at the Palm Beach docks on the left.

George B. Baker, born 1854 in Florida, came to West Palm Beach in 1901 as an employee of the Florida East Coast Railroad. Baker served as mayor of West Palm Beach from 1905 to 1907, and in 1909, Gov. Albert W. Gilchrist appointed him sheriff (1909–1920) of the newly formed Palm Beach County. His son, Deputy Sheriff Robert C. "Bob" Baker was promoted to sheriff when George died.

The Lake Worth Band provided entertainment in the late 1890s. Its members were, from left to right, (first row) Edward C. Gross, George Lyman, Dr. William Broadwell, George L. Branning, John B. Beach, Alva L. Haugh; (second row) Martin Courtney, H. F. Bubb, Walter J. Haugh, J. F. Pace, Louis Burkhardt, Arthur B. Weaver, Carl Lauther, Henry Sanders; (third row) C. W. Schmid, W. E. Young, and W. C. Minick.

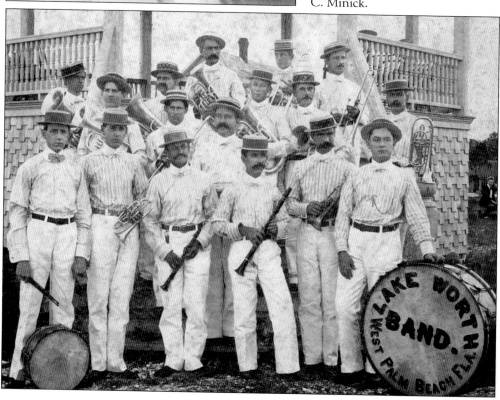

Alford P. Sadler celebrated his 21st birthday at the fire station on October 5, 1909. From left to right are (seated) Charles Pierce, Mack Crosby, Elmer Schultz, Lawrence Covar, unidentified, Grady Creech, unidentified, Hoyt LeMaster, and Murl Ralph; (standing) Alford Sadler, Carl Kettler, Frank Ahrens, Grover Chick, Henry Burkhardt, John Cheatham (the fire chief), Joseph Borman, C. Barnett, William Vass, Walter Wells, and Bob Baker.

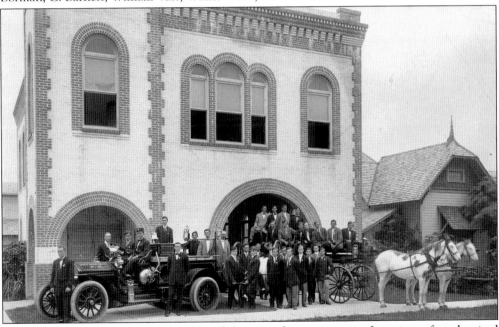

The fire department compares the old and the new after receiving its first piece of mechanized equipment in 1911. This modern vehicle was a vast improvement over what J. L. Marvin, the foreman of the Flagler Alerts (as the first volunteers were known), had when the fire department was organized in 1894. That fire-fighting equipment had only included a "hand engine hose reel, hose and accoutrements for the members."

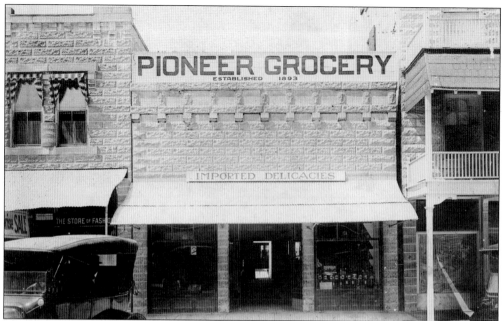

Louis and Henry Burkhardt opened their first business, Burkhardt Brothers, on the Royal Poinciana Hotel grounds in 1894 selling fruit and oysters. Located where Flagler Museum now stands on Palm Beach, the wood and tent store was loaded onto a barge, ferried to the west side, and placed at 207 Clematis Street, the first lot sold in West Palm Beach. By 1916, the brothers' Pioneer Grocery had been modernized.

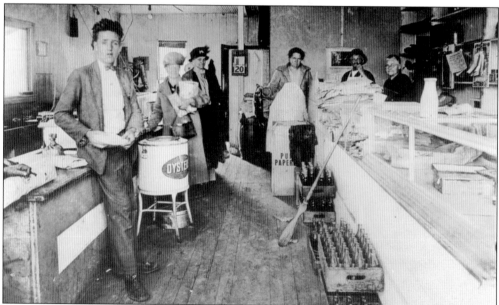

One can see the modern conveniences and food preferences of the day in this photograph, marked only "Pioneer Grocery," which could be the interior of Burkhardt's grocery store. Oysters, which probably came directly out of Lake Worth, deserved their own fixture. Clerks used white butcher paper and string to wrap purchases, and what appear to be beer bottles line the floor under the counter.

22

Louis William Burkhardt brought his family from New Jersey to the Lake Worth area in 1893, joining his brother, Henry John Burkhardt, who had arrived several years earlier. Louis became a West Palm Beach mayor in 1902 and served as a town alderman and a judge. Henry, the last of the barefoot mailmen, felt that full exposure to the sun was healthy as he walked the remote portions of the route along the beach.

In 1894, A. P. "Gus" Anthony borrowed money to purchase a small store in Titusville. The following year, Gus followed Flagler to West Palm Beach, and in October 1895, he opened the first Anthony's store at a counter in the post office at the Palms Hotel. He opened his second store next door, advertising "Anthony's Shoes Are Silent Salesmen," on the corner of Clematis and Narcissus Streets.

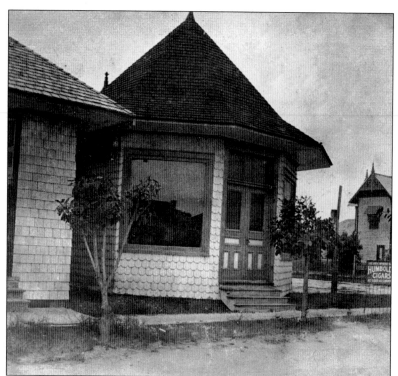

The Dade County State Bank opened in 1893 in Palm Beach. The octagonal building was moved in 1897 by barge from Palm Beach to Clematis. Over the years, the old bank building housed a number of different businesses, including a juice stand, a dental office, and Johnny's Playland. In 1978, it was moved to its latest resting place and is now the Palm Beach High School Museum.

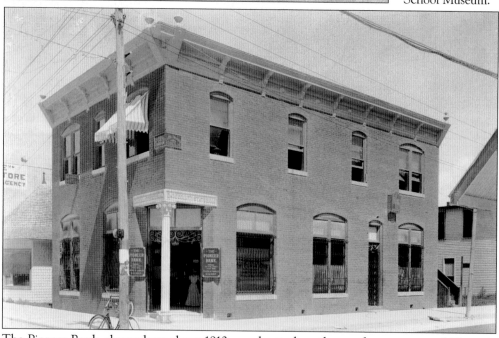

The Pioneer Bank, shown here about 1912, was located on the northwest corner of Clematis Street and Olive Avenue. Formerly the Dade County State Bank, the name was changed when Palm Beach County was created in 1909. The sign at the entrance states capital and surplus of $65,000, and the sign on the second floor advertised the office of Charles Curtis Chillingworth, Attorney at Law.

Guy Metcalf founded the *Indian River News* in 1887 in Brevard County, Florida. He relocated to Juno in 1891, and his newspaper became *The Tropical Sun*. Metcalf moved to West Palm Beach in 1895, sold his newspaper to Flagler's Model Land Company in 1902, and was elected as a trustee of Dade County's School District Number 1 in 1904. He was appointed postmaster of West Palm Beach in 1913 and was superintendent of Palm Beach County schools in 1917 when this photograph was taken. In February 1918, the school board swore out a warrant for his arrest and suspension for forgery. Confiding in a friend, he admitted having no recollection of his actions. Metcalf was found in his office the next morning, having taken his life with a pistol. (Courtesy School District of Palm Beach County.)

Dr. Warren Hale Collie, son of John M. and Amy Warren Collie, was born September 18, 1894, in St. Augustine, Florida. In June 1917, Collie finished dental school and by September 1918 was in France, serving as a dentist with the 808th Pioneer Infantry. One of the first black dentists to practice in West Palm Beach, Collie was honored in 1969 for his 50 years in dentistry.

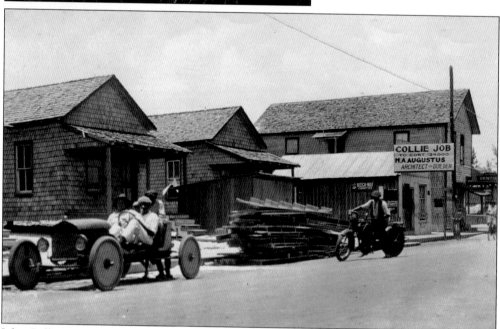

John Collie, Warren's father, was originally from Nassau, Bahamas, and moved his family to West Palm Beach sometime before 1910. John worked many years as a bartender and saloon keeper while owning a cigar store, pool hall, and an apartment building in the Rosemary Avenue and Banyan Street area. Dr. Warren Collie had his dental office on the right.

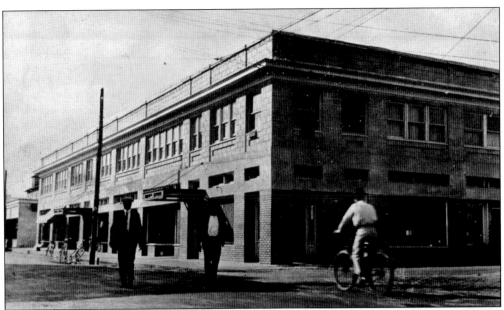

Hazel A. Augustus designed and built the Collie Building, shown here about 1920, for Dr. Warren Collie. Augustus was born July 1, 1887, in Orlando, Florida. A self-employed contractor in West Palm Beach, he became the city's first black architect, constructing such notable buildings as Payne Chapel AME Church and the Tabernacle Baptist Church. Augustus died in a traffic accident in 1926.

Originally from New York, Joseph Mendel was advised by his doctor to move south to a warmer climate for his health. A cigar manufacturer, Mendel arrived in Florida in 1908 and was elected to the West Palm Beach City Council in 1923, which in turn appointed him mayor. Mendel held the position as the city's first Jewish mayor for two years and later became involved with banking and real estate.

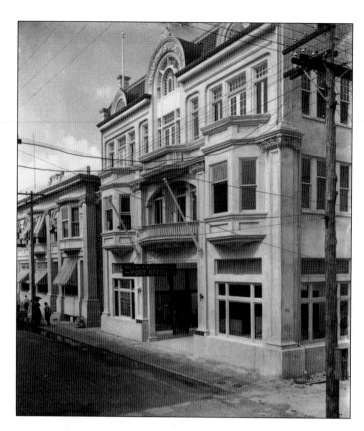

The Italianate Metcalf Building on North Olive Avenue was built sometime around 1895. After 1912, the building became known as the Pioneer Bank and post office. George Hatch leased the three-story Metcalf Building around 1925 and, in 1936, hired architect John Volk to incorporate the Metcalf Building and the building adjacent to it into a modern design. Burdines purchased Hatch's Department Store in April 1941.

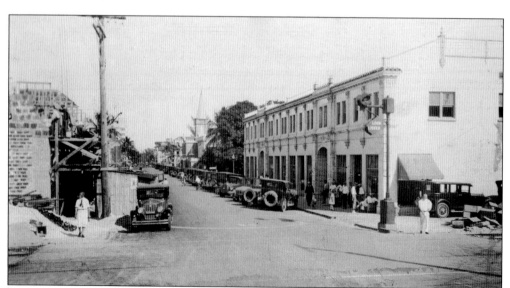

Looking east down Datura Street in October 1925, the fourth U.S. Post Office in West Palm Beach was located in the arcade on the right side of the road, adjacent to the Florida East Coast Railway tracks. Shortly after the post office moved here from the Metcalf Building, there was an explosion caused by a gas leak. The janitor was severely burned, and damage was estimated at about $10,000.

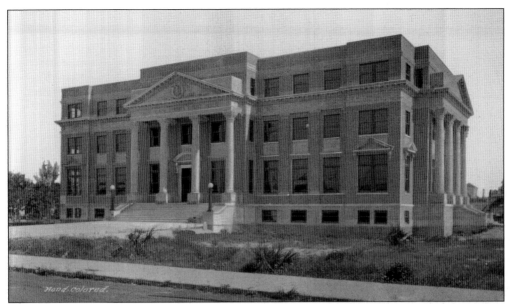

Construction of the 1916 courthouse was delayed because of controversy over costs and procedures. The building held all county government offices including the jail. Expanding for the needs of the rising population of Palm Beach County, an annex was added in 1927, and an office building was constructed on Datura Street in 1955. Despite opposition, this stately neoclassical courthouse was encased in a wraparound addition that was completed in 1972.

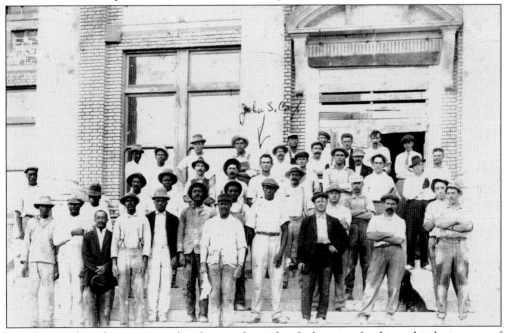

It took more than three years to plan the courthouse but far less time for this multiethnic group of workers to complete the project. The dedication was held in April 1917 just after this photograph was taken. The courthouse is presently being restored, and part of the old courthouse will once again house county offices. The Historical Society of Palm Beach County will transform the rest into a history museum.

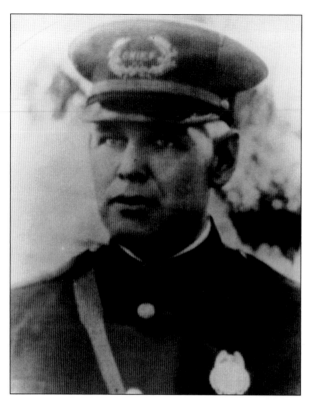

Frank H. Matthews, the last official town marshal, had his title changed to chief of police when the council reorganized city government in 1919 and he no longer had to act as tax collector. Matthews's department was comprised of a grand total of eight men. His son, Trueman, was elected police chief in 1948 and hired the city's first black police officers.

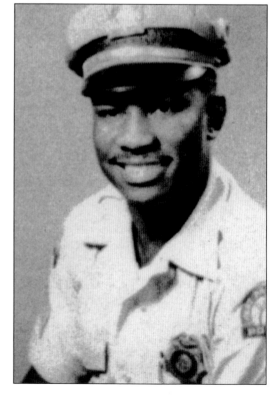

Officer William Boone Darden was one of the first black officers hired by the West Palm Beach Police Department in 1948, along with A. Harley Wilson, Primus L. Greene, and Dwight W. Bolen. They had their own precinct house at the old jail at Rosemary Avenue and Banyan Street. By 1959, Darden had been promoted to sergeant and was elected chief of police in Riviera Beach, Florida, in the 1970s.

Two

CLEMATIS STREET AND THE BUSINESS DISTRICT

Most communities have a central part of the city that is the focal point of commerce. Since 1894, Clematis Street has been center of business. Though all the streets were laid out in 1893, it was Clematis Street that became the center of the business district. The first business, a hardware store, opened in a tent and wood structure. Soon after, Clematis flourished with businesses, shops, hotels, and skyscrapers. Developers and businesses expanded to the surrounding streets, adding more commerce to the city.

In the 21st century, Clematis Street is still going strong with retail stores, restaurants, shops and businesses, and Clematis by Night, a once-a-week entertainment event drawing in local residents and tourists. What follows are just some of the early businesses and people that were involved with establishing West Palm Beach as a commercial center.

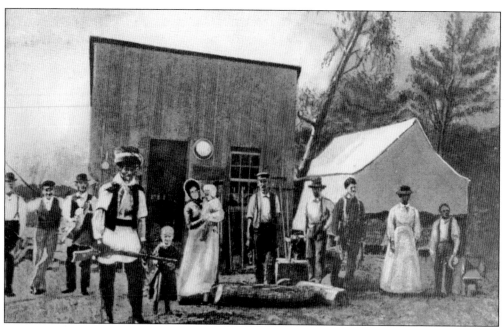

Otto and Mary Weybrecht opened the first business, a hardware store, in West Palm Beach on Clematis Street in 1894. The Weybrecht home was the tent to the right. Pictured from left to right are an unidentified fisherman, "Ikey" Simmons, Dr. J. A. Pugh (one of the first dentists), Seminole chief Billy Bowlegs, Price W. Weybrecht, Mary Weybrecht holding baby Willie, Otto W. Weybrecht, two unidentified men, Minerva Reddick, and Sylvester Reddick.

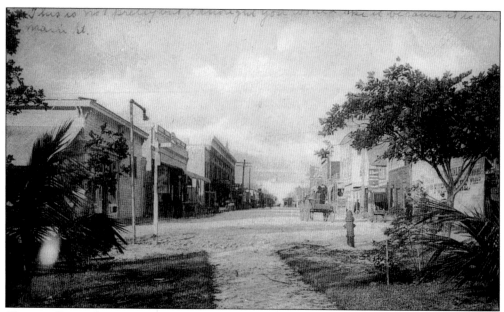

Clematis Street, the main east-west thoroughfare and business district of West Palm Beach, was still just a dirt and crushed-shell road when this photograph was taken about 1907. Looking east from City Park, there is but one horse-drawn wagon. It would still be a few years before the road would be paved with asphalt and automobiles would fill the street jockeying for places to park.

Joseph Jefferson (1829–1905), a famous 19th-century, fourth-generation actor, was an important developer in the fledgling town. His contribution to West Palm Beach was second only to his friend Henry Flagler. Jefferson was responsible for building the first ice and electric light plants in West Palm Beach as well as the building of the Jefferson Block. He died April 23, 1905, in Palm Beach.

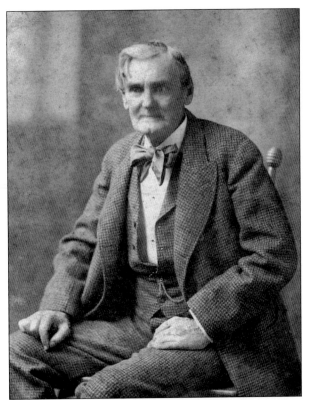

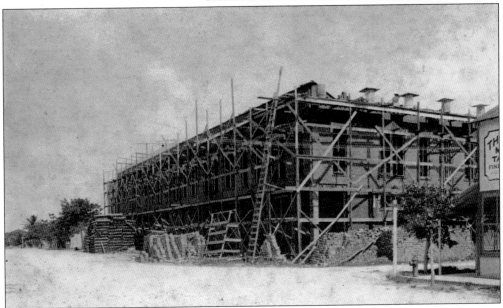

The Jefferson Block was a brick two-story structure on the southeast corner of Clematis Street and Olive Avenue that housed six stores. Jefferson built another commercial building across the street on the northeast corner for Anthony Brothers' dry goods store as well as the Jefferson Hotel. Jefferson's home, on the corner of Datura and Narcissus Streets, was directly across from six houses he also owned and rented out.

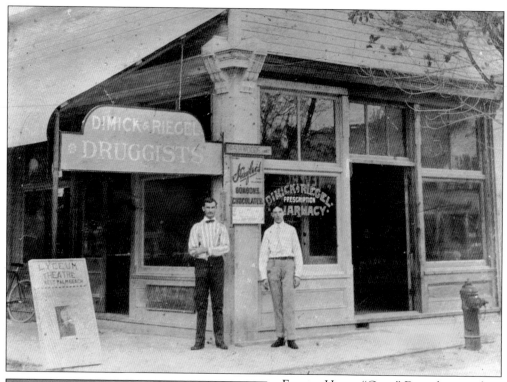

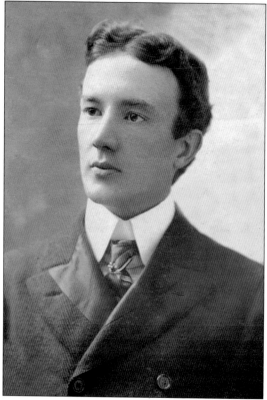

Eugene Henry "Gene" Dimick, son of Franklin L. Dimick, was one of West Palm Beach's first seven aldermen. Between 1894 and 1896, he took over the drugstore purchased by his uncle Elisha N. Dimick from E. M. Hyer of Orlando. The drugstore, shown about 1901, was the first pharmacy in West Palm Beach.

Located at the corner of Clematis and Narcissus Streets, the present site of the Citizens Building, Dimick Pharmacy sold drugs, patent medicines, sundries, stationery, account books, schoolbooks, perfumes, cigars, tobacco, and pipes. Eventually Dimick took on Mr. A. G. Riegel as a partner, and they changed the name to Dimick and Riegel Prescription Pharmacy. A. G. Riegel is pictured here about 1901.

James Bernardo McGinley, proprietor of J. B. McGinley and Company House Furniture Store, was born in Scotland in 1874. He came to West Palm Beach in 1899 and sold furniture, hardware, and real estate from the store on Clematis he opened in 1901. In addition, he and his brother worked as undertakers out of the back of the store. McGinley served as mayor from 1910 to 1912 and died in 1952.

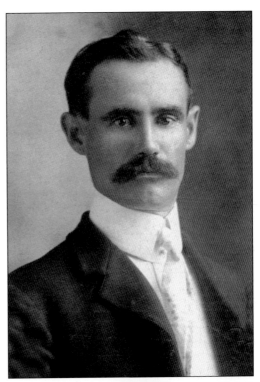

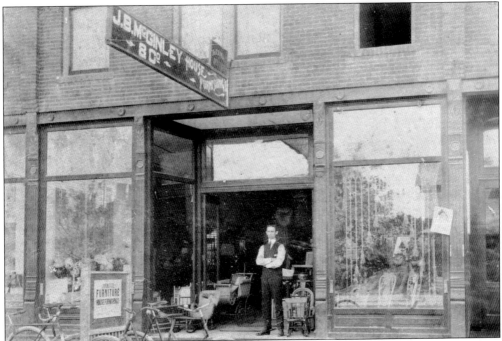

Harry Patrick McGinley stands in the doorway of the J. B. McGinley and Company House Furniture Store in 1903. Born in Indianapolis on March 16, 1877, Harry joined his brother in West Palm Beach in October 1902 and established his own business, McGinley Realty Company, in 1910. Harry died March 14, 1939, in Asheville, North Carolina.

From the west end of the Florida East Coast Railroad bridge, the Seminole (on the right) and Palms Hotels mark the high points of West Palm Beach's skyline in 1900. Anthony Brothers' advertised their store on the shoreline with a large waterfront billboard. The modest dock just south of the bridge allowed people with their own boats from around the lake access to downtown.

Looking west from a boat off City Dock, the Holland House Hotel is on the left horizon followed by the Salt Air Hotel. City Park was just beyond the Free Reading Room that was located at the base of City Dock. Local fisheries followed the Palms Hotel and the Seminole Hotel on the right side of this early-1900s photograph.

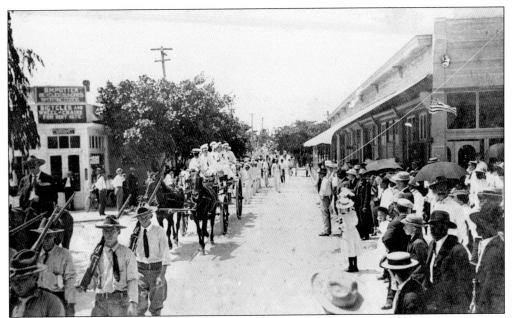

Members of the "Home-Guard" proudly marched north on Narcissus Street during the Fourth of July Parade in 1908. Wilbur Warren Hendrickson is shown at left on horseback. A Dade County deputy sheriff and jailor, Hendrickson was killed on June 2, 1915, by Bob Ashley, who was trying to rescue his brother, the infamous John Ashley, from a jail in Miami. Ben Potter's Bicycle and Wheel-Chair store is on the left.

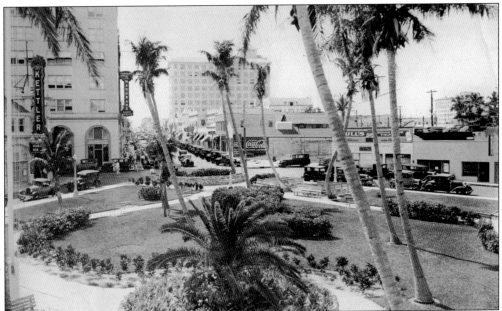

Looking west from City Park in the 1920s in the days before air conditioning, office workers opened their windows to catch the cool ocean breezes. Hull's Indian River Fruit can be seen on the northeast side of Narcissus and Clematis Streets where locals could pick up fresh, Florida-grown citrus. City Park was a popular meeting place with a band shell, a library, and flower-bordered walking paths.

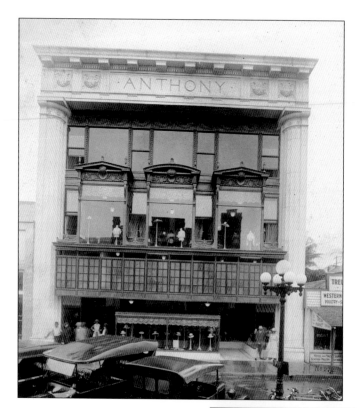

Augustus P. "Gus" Anthony opened a "men's haberdashery" in October 1895 on a counter at the post office in the lobby of the Palms Hotel. Eventually Anthony's converted into a women's clothing store. The building constructed in 1917 on Clematis Street remained the anchor for what became a chain of stores until 1985. Anthony's fashion business is the second-oldest business in the county.

Emile DuBose Anthony Sr., younger brother of A. P. "Gus" and James R. Anthony, took over the responsibilities of running Anthony's so his brothers could spend more time with their banking businesses. In the 1940s, Emile and his sons began buying land west of town that became Anthony's Groves in 1966. Emile Sr. died in 1965, and his sons, Marvin Pope "Ham" and Emile Jr., took over the business. (Courtesy Anthony family.)

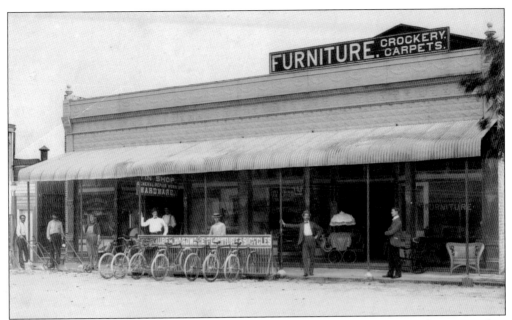

Marion Eugene "M. E." Gruber, son of a railroad engineer from South Carolina, moved to Titusville, where he worked as a mail agent and married Lena Nelson Decker in 1888. They established M. E. Gruber Hardware on Clematis Street in February 1896. Pictured from left to right in 1899 are Capt. Everard E. Geer, John O. Cheatham, Patrick Lennon, Joe Sanders, Noah Jones, an unidentified customer, M. E. Gruber, and W. F. Armstrong Jr.

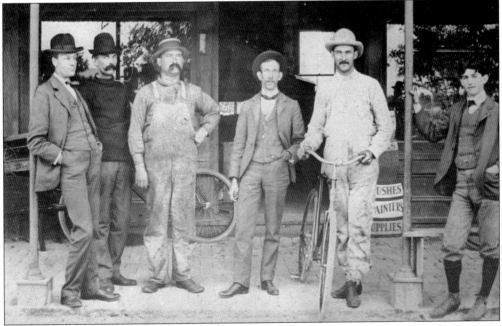

Pictured in front of M. E. Gruber's Hardware Store on Clematis Street from left to right are James B. McGinley, unidentified, Patrick Lennon, Marion Eugene Gruber, Harry DuBois holding a bicycle, and an unidentified man. The Dimick and Riegel drugstore was on the left side of the store, and George H. Maltby's furniture store was on the right.

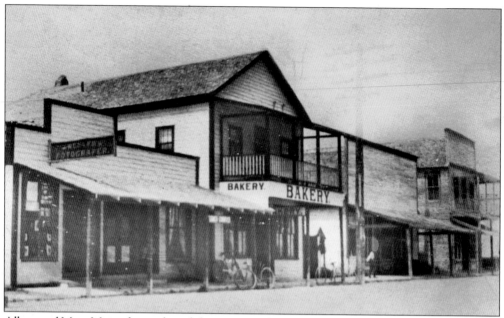

Albert and Mary Majewski purchased this two-story building on Clematis Street from J. W. Grimes sometime between 1896 and 1900, establishing a bakery on the first floor and living on the second. Albert died in 1909, leaving Mary with seven children and a bakery to run. She sold the successful business and building to Ewing Graham in 1920 for $50,000, a city real estate record.

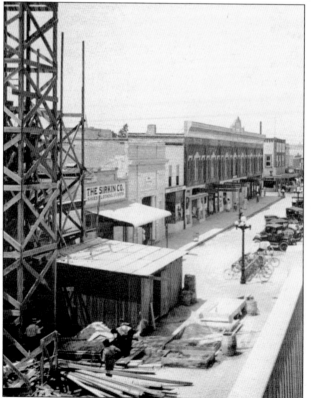

Max Sirkin established the Sirkin Company, a shoe, clothing, and hat store on Clematis Street in 1896. Shown here in 1916, the Sirkin Company was located on the west side of the Palm Beach Mercantile building that was being remodeled. He sold the business to the Palm Beach Shoe Company in 1919. Sirkin, born about 1870 in Russia, came to the United States in about 1880. He died on June 4, 1933.

A New York businessman, William Harley DaCamara, came to DeLand, Florida, in 1886 when he inherited a citrus grove there. Forced out of business by a freeze, DaCamara arrived in West Palm Beach, becoming a partner in William Hatchett's small hardware business in 1901. In 1907, M. E. Gruber and DaCamara built the Lake Worth Mercantile Company, later changed to Palm Beach Mercantile Company. DaCamara died in Franklin, North Carolina, in October 1931.

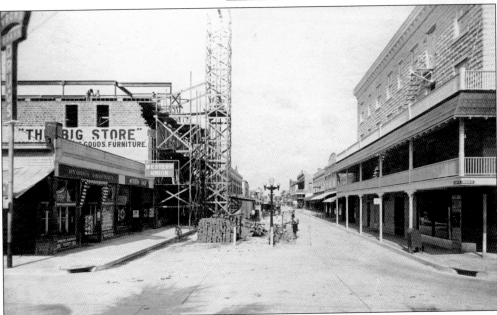

The Palm Beach Mercantile Company, located on the original site of Gruber's hardware store, was remodeled in 1916. Hatchett-DaCamara Hardware and M. E. Gruber Hardware consolidated as Lake Worth Mercantile Company in 1907. They changed the name to Palm Beach Mercantile Company after the town of Lake Worth was formed. The partnership constructed a four-story annex at Datura and Narcissus Streets to combine the two buildings.

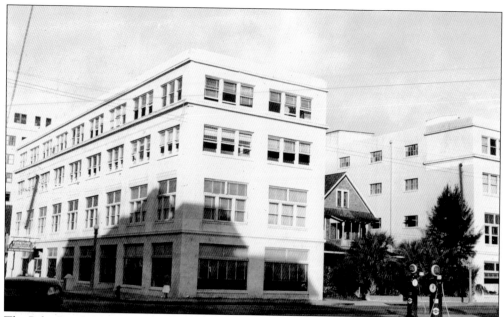

The Palm Beach Mercantile Building at the northwest corner of Datura and Narcissus Streets is shown here about 1936. The building was six stories high by 1924 and had the city's first elevator. Palm Beach Mercantile Company, the first large business block in the city, went out of business in the late 1950s. Now the Harris Building, it was listed on the National Register of Historic Places in 1994.

Bernard "Ben" Miller Potter, the adopted brother of George, Richard, and Ellen Potter, arrived on Lake Worth in 1885. He operated a bicycle and wheelchair store on Narcissus Street but retired as a hardware clerk from the Palm Beach Mercantile Company. Potter also served as a town councilman and died in West Palm Beach in 1951.

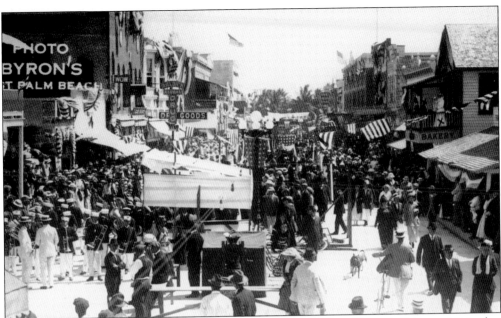

The first Armistice Day celebration in West Palm Beach was held on Clematis Street on November 11, 1919. Revelers dressed in their best commemorated the first anniversary of the end of the Great War with band music and speeches. After World War II, Armistice Day was changed to Veterans Day in the United States. Majewski's Bakery is the two-story building with spectators on the second floor to the right.

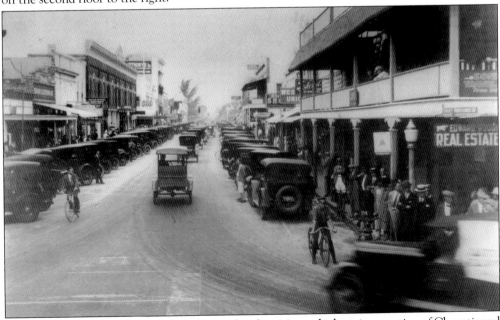

Speeding vehicles compete with bicyclists and pedestrians at the busy intersection of Clematis and Narcissus. Parking on Clematis changed as automobiles became more affordable to the masses, creating a need for more parking spaces. By the mid- to late 1920s, cars angled in on the south and parallel parked on the north. Interested investors line up in front of one of the many real estate businesses in West Palm Beach.

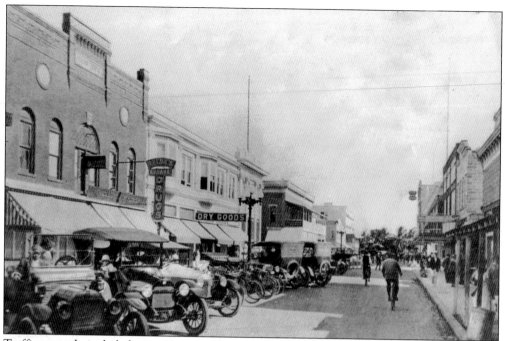

Traffic was relatively light on Clematis Street in 1916, and people parked in the center of the street and crossed traffic to get to the sidewalks. The brick building on the left is the Masonic Temple, and just beyond, Relbe's Drug Store advertised Kodak film and cameras. The Dry Goods Store is beyond the drugstore.

Simon "Cy" Argintar, born in Romania in 1893, left Bremen and arrived on Ellis Island on November 11, 1913. He joined other Argintar family members in Asheville, North Carolina, where he worked as a men's clothing salesman. A relative convinced him to start a business in West Palm Beach, where he arrived in 1922 and established Cy's Men Store. He died in West Palm Beach in 1968.

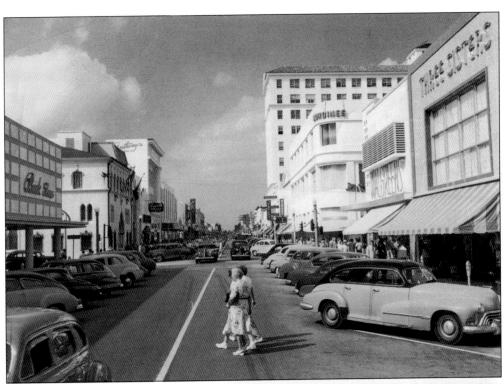

Burdines opened on Clematis in 1925 but closed during the Depression. It reopened in 1941 after buying and renovating Hatch's Department Store at Clematis and Olive Avenue. The store moved to the corner of Clematis and Dixie Highway, where it remained until 1979 when it moved to the Palm Beach Mall. Federated Department Stores bought Burdines in 1956 but dropped the name in 2005 when the conglomerate merged Burdines with Macy's.

Max Greenberg, born in Austria in 1886, came to the United States about 1907 and was in Daytona by 1910. Lured farther south by new development, Greenberg settled in the town of Lake Worth in 1912. Finding conditions there primitive, he named his business Pioneer Hardware. After the 1928 hurricane destroyed his store and warehouse, he moved his business to Clematis Street, where Pioneer Linens has been ever since. (Courtesy George Greenberg.)

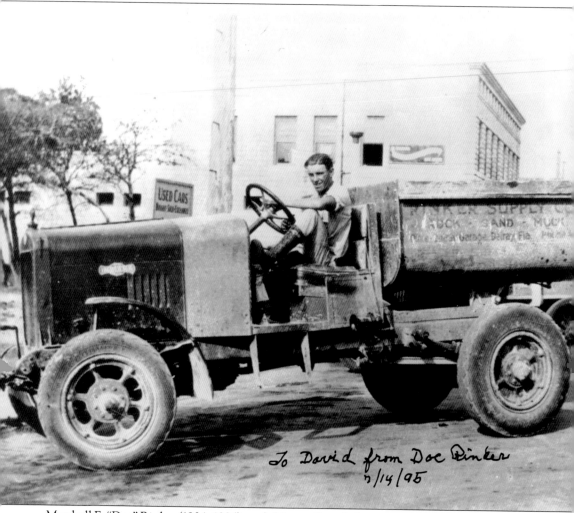

To David from Doc Rinker
7/14/95

Marshall E. "Doc" Rinker (1904–1996) made his way from Indiana to Palm Beach County in 1925 driving a Model T. In order to fill an empty niche in the construction industry, Rinker bought a dump truck with borrowed money and started a concrete and hauling business. His reputation for honesty, integrity, risk taking, and hard work made him extremely successful. Doc persevered, and Rinker Materials eventually became the largest concrete producer in Florida. When Rinker Materials Corporation sold for over $515 million in 1988, Rinker became a full-time philanthropist, giving millions to what he most believed in: education, religion, and the arts. The Marshall E. Rinker Sr. Foundation continues to support the ideals of its founder through the leadership of his son David. Doc Rinker's fortunes were directly linked to the growth of West Palm Beach.

Three

REAL ESTATE
Boom and Bust

Early real estate agents in West Palm Beach sold land to the industrious, who in turn developed it for construction of businesses and homes from the late 1890s to the 1920s. However, construction slowed when the United States entered World War I. As the nation emerged from a recession brought on by the end of the war, building increased as real estate became a valuable commodity.

As brochures extolled the beauty and wonderful climate of Florida, thousands of people across the United States rushed to purchase land for investment and development. Local architects and contractors were kept busy designing hotels, office buildings, and residential communities. One of the most prolific architectural firms in West Palm Beach was Harvey and Clarke, who designed many of the city's main buildings in the 1920s. There was such an explosion of growth that in just a five-year period, city property values went from $13 million to $61 million.

Two devastating hurricanes, negative publicity about bad land deals, and fraud brought the booming real estate market to a halt. Banks closed and investors went bankrupt across south Florida. Then came the stock market crash of 1929 that sent the United States into the Great Depression. By the end of the following year, more than 10 banks in Palm Beach County had closed their doors. In the mid-1930s, property values in West Palm Beach, which had topped $89 million, dropped to $18 million. Notwithstanding the low property values, there was some growth in the city, which was supported by federal government programs such as the Works Progress Administration (WPA) and the Public Works Administration (PWA). These federal programs helped put people to work and kept some development going in West Palm Beach.

George Graham Currie, born near Montreal in 1867, was in New York by 1895 when he decided to go to Cuba as a newspaper correspondent to report on the insurgency there. He traveled to Key West to gain passage but was unsuccessful. Currie left Key West in a small schooner and arrived in West Palm Beach, where he worked as a stenographer for the Robbins, Graham, and Chillingworth law firm. While there, Currie studied law and was admitted to the Florida Bar in 1897, afterward becoming a partner with Charles C. Chillingworth. Currie was elected mayor of West Palm Beach, serving two terms from 1901 to 1902 and 1902 to 1904. He created the Currie Investment Company in 1907 and was treasurer of Dade County. Currie published almost 18 books of essays, poems, and musical lyrics before he died in 1926.

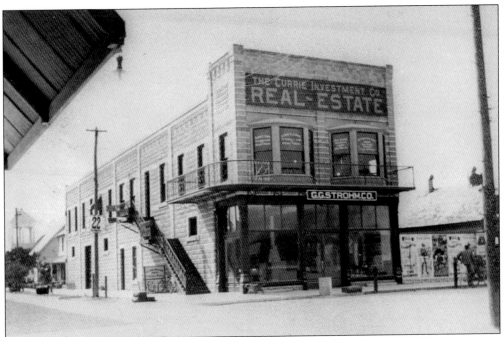

In 1907, the Currie Investment Company was located on the second floor of a two-story building at Clematis Street and Olive Avenue. The site later became the Farmers Bank and Trust, which was built in 1913. The G. G. Strohm grocery store occupied the first floor and was operated by Glenn G. Strohm and his partner, E. L. Brady. Strohm died in 1919 and is buried at Woodlawn Cemetery.

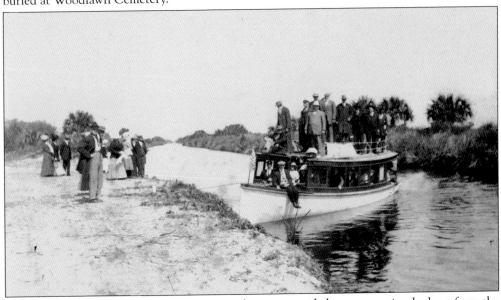

Interested real estate bidders at an auction sale were provided transportation by boat from the city dock to the site of an unidentified subdivision about 1920. Another real estate company, City Builders Realty Company, advertised a large amount of free dollar bills to be given away by auctioneer W. J. Willingham. Willingham was the first auctioneer credited with giving away money and providing entertainment to prospective buyers.

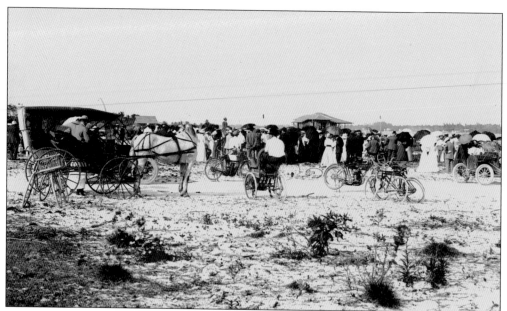

Lots are auctioned in Bethesda Park, also known as Currie Park, about 1912. The Currie Investment and Title Company owned and developed the subdivision of Bethesda Park along the lakeshore. The subdivision was one of the residential areas developed by local land companies. This was at the beginning of the land boom, and people hungry for land would travel by car, horse-drawn wagon, bicycle, and wheelchair.

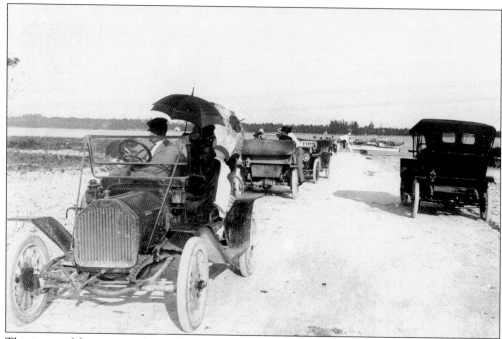

This is one of the auctions that took place at Bethesda Park. During the land boom, these auctions were commonplace as people poured into the area looking to make it rich by investing in property then turning around and selling it for a profit. Lake Worth is in the background as is the round roof of the second Bethesda-By-The-Sea Church, shown about 1912.

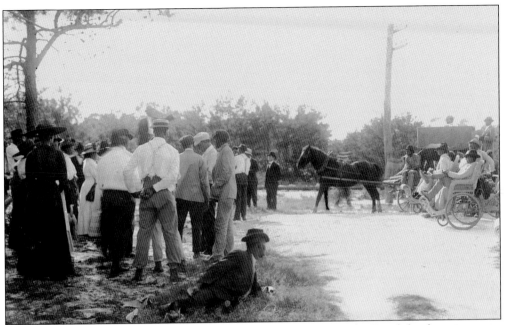

A group from the African American community attends a West Palm Beach land auction, near the Florida East Coast railroad tracks. The gentleman playing the piano on the wagon at the far upper right provided musical entertainment for prospective buyers, some of whom arrived in wheelchairs like the one in front of the piano player's wagon. Wheelchairs were a common mode of travel in the early history of the Palm Beach and West Palm Beach.

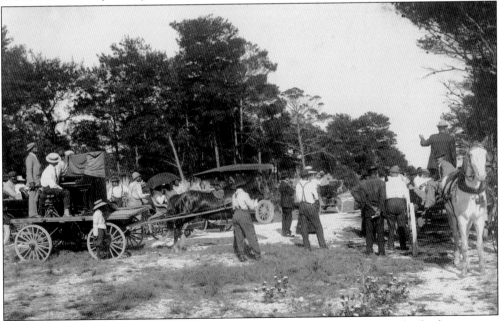

Looking in the opposite direction, the real estate auctioneer is standing on the back of a wagon on which a sign reads "Mrs. F. E. Holley, West Palm Beach." Mrs. Holley was a dry goods merchant with a store at 222 Clematis Street and her home at 319 Gardenia Street. The man standing behind the piano player has a trumpet in his hand.

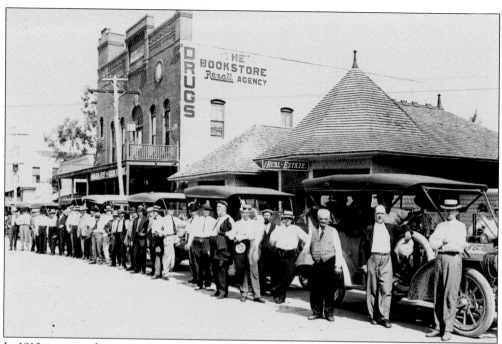

In 1913, investors line up in front of Frank Sheen's real estate business on Clematis Street, which was once the Dade County State Bank building. Sheen came to West Palm Beach in 1893 and worked as an engineer for Henry Flagler's Florida East Coast Model Land Company. He served as county surveyor and was involved in road construction and real state. Sheen died of tuberculosis in 1917.

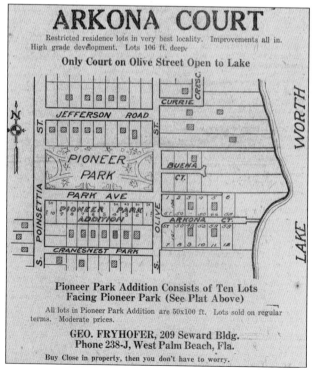

Real estate companies offered land sales through many different means. This 1922 advertisement for Arkona Court subdivision is just one of many subdivisions with lots available for sale by realtors in West Palm Beach. George Fryhoffer, president of Fryhoffer Land Company, was one of more than 20 real estate companies operating in West Palm Beach during the land boom. Pioneer Park was located where the Norton Museum of Art is located today.

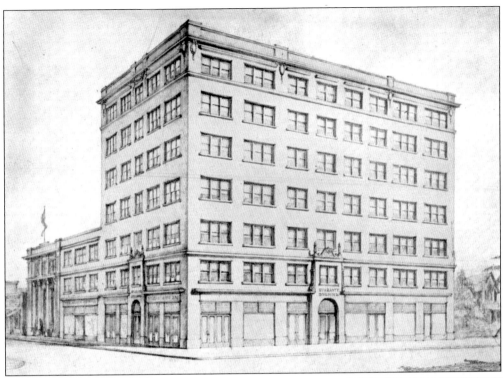

The Palm Beach Guaranty
Company's seven-story Guaranty
Building is located at 120 Olive
Avenue and was designed in 1922
by Henry Harvey and Phillips
Clarke. The company provided
the financing for the Lake
Court Apartments, Northwood
subdivision, and North Shore
Terrace in West Palm Beach.
According to reports of the day,
the building had more square
footage than any other building in
the state.

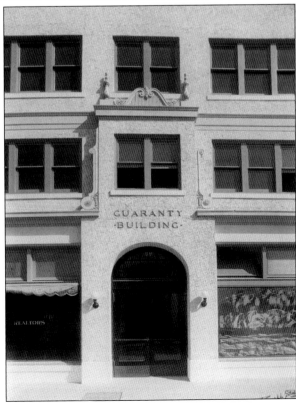

The front entrance to the Guaranty
Building is shown c. 1922. To the
right on the first floor are Pearson's
Prescription Pharmacy and the
Datura Drug Company. On the
second floor above the doorway
is the Dougherty Brothers and
Company, Inc., a real estate and
investment company. Raymond
Yeomans, an attorney had his law
office is on the third floor.

Atlanta architect G. L. Preacher designed the Citizens Bank Building located on the former site of the Dimick and Riegel drugstore on the southwest corner of Narcissus and Clematis Streets. It was built for the Citizens Investment Company and opened in 1923. The seven-story structure had a bank on the first floor and various company offices on other floors. During the Depression, the property was sold through foreclosure proceedings.

J. S. Willson, a local builder specializing in Spanish architecture, built the Datura Arcade at 300–310 Datura Street. The arcade housed real estate offices and a Spanish-style patio tea garden. In 1924, Willson's company handled about $1 million worth of business. He built Spanish-style houses in the West Palm Beach subdivisions of Northwood, El Cid, and Prospect Park and residences and apartments in Palm Beach.

The Harvey Building at the southeast corner of Olive Avenue and Datura Street is 14 stories and has 234 rooms. When it opened in 1927, the skyscraper towered seven stories higher than any other building in the city. Developer George W. Harvey obtained a 99-year lease from the Chillingworth family, who owned the corner lot where Harvey constructed his office building, for a consideration of over $3 million.

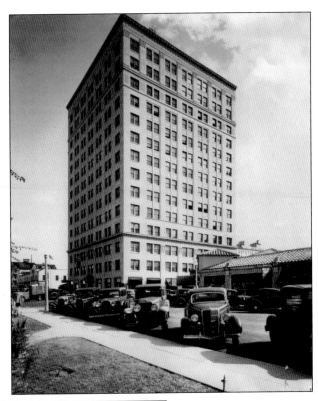

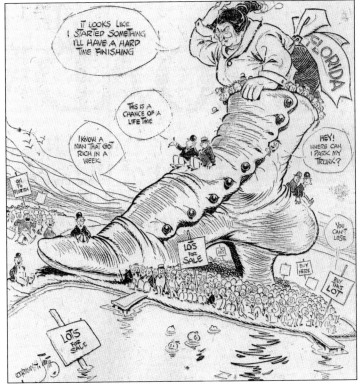

This cartoon appeared in the *Palm Beach Post* in 1925 at the height of the land boom. It is representative of just how quickly people were coming to the state to invest in real estate. Both buyers and sellers were looking for fast returns on their investments. The boom began to decline the following year because of hurricanes, fraud, and a shortage of building materials.

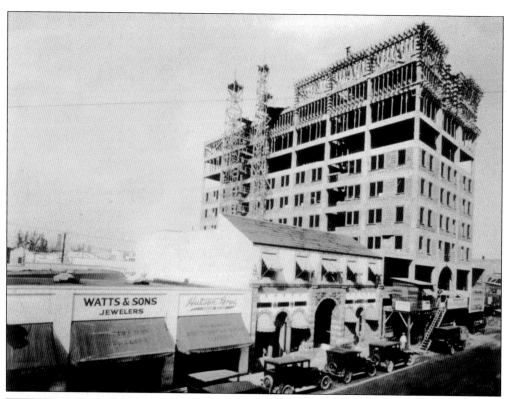

WATTS & SONS JEWELERS

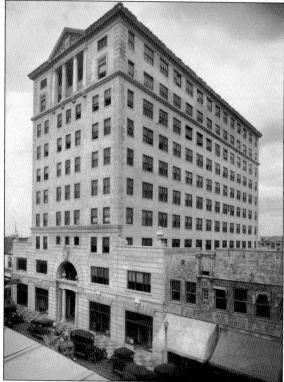

The Comeau Building is under construction on Clematis Street. Commissioned by Alfred J. Comeau, this 10-story building was designed by architects Harvey and Clarke and opened in 1925. Comeau, a financier and businessman, opened the Comeau Café on Clematis Street in 1916. When he decided to build an office building, he chose the site of his restaurant at 317 Clematis Street. Harvey and Clarke also designed Comeau's home on Flamingo Drive.

The neoclassical Revival–style Comeau Building had 100,000 square feet and was one of the tallest structures in the city. Harvey and Clarke were responsible for designing many of the city's landmark buildings in the 1920s. The first five buildings the firm designed were drawn by Harvey, including the Comeau Building. From 1924 to 1926, Harvey served as mayor of West Palm Beach.

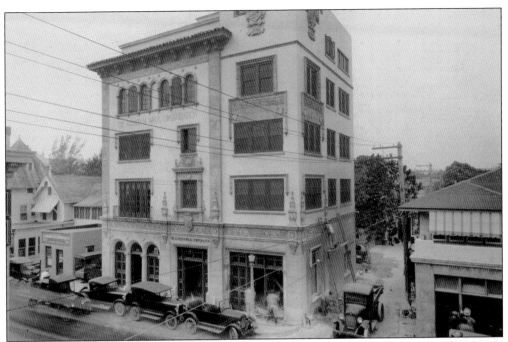

Alfred H. Wagg built the office building, known as the Wagg Building, at 215 South Olive Street for his corporation in 1926. Designed by the local architectural firm Harvey and Clark, the four-story structure is based on styles found in Andalusia, Spain, with original design adaptations to the fresco ornamentation detail. The Depression brought hard times when the Central Farmers Trust Company filed a foreclosure suit against Wagg.

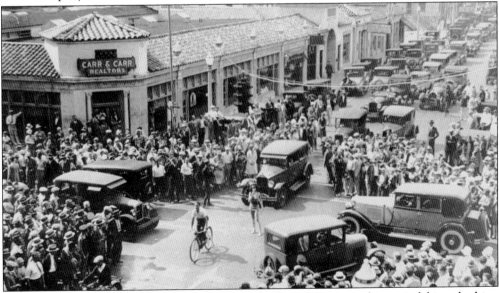

A crowd at the intersection of Datura Street and Olive Avenue watches a model in a bathing suit direct traffic in front of the office of Carr and Carr Realtors, located in the Datura Arcade, about 1926. Established in 1923 by brothers George W. and Oliver B. Carr, the company was a reputable business for both buyer and seller. The brothers were also individually involved in other local businesses.

At the decline of the land boom and after the stock market crash, individuals, investors, banks, and companies faced financial disaster at the end of the 1920s and into the following decade. Real estate investors went broke overnight as property values declined rapidly. Banks failed because loans could not be collected and people withdrew their money, as seen here at the Farmer's Bank and Trust in West Palm Beach.

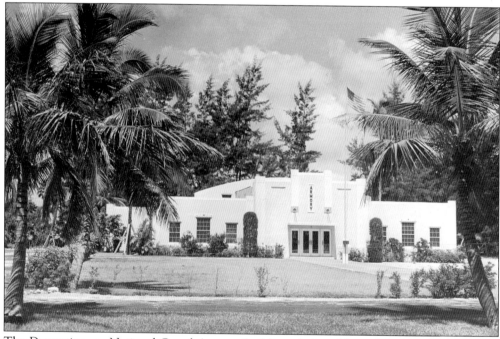

The Depression-era National Guard Armory Building, designed by architect William Manley King, was built in 1939 as part of a WPA project. The art deco–style structure was constructed on the former site of the West Palm Beach Farmer's Market in Howard Park at 1703 South Lake Avenue. It was used by the Florida National Guard until the 1980s and then converted into today's Armory Arts Center.

Four

PLACES TO STAY, THINGS TO DO

Since the 1880s, the Lake Worth area has been a desirable location for visitors and workers. When West Palm Beach was founded, hotels were needed for tourists and new arrivals moving here. A couple of early houses were converted into hotels. As the city expanded, the middle class found West Palm Beach a great place to vacation. Larger hotels were built to accommodate them with the most modern conveniences of the time.

For locals and tourists, there was plenty to do in the area. If they wanted to swim in the ocean, people traveled to the beaches in Palm Beach to enjoy a day of sun and surf. Boaters could be found on both the ocean and the lake. At the height of the tourist season, the lake was crowded with various types of watercraft. The ever-popular sport of fishing is a delightful way to spend the day. The Silver Sailfish Derby, established in 1935, drew anglers from the surrounding area and from out of state to compete for prizes.

Local entertainment included baseball, tennis, theaters, concerts, museums, celebrations, and parades. Everyone played baseball, and merchants would close their shops for an afternoon to play a game in Flagler Park. Major league baseball teams came to West Palm Beach for their spring training and played exhibition games at Wright Field. Golf, introduced in Palm Beach by Henry Flagler in the 1890s, is an extremely popular sport, especially here. Palm Beach County may be the "golf capital of the world," with over 160 golf courses in the county. From 1916 to the 1950s, the annual Seminole Sun Dance celebration was held every March to the delight of residents and tourists and currently continues in the form of the yearly Sun Fest held yearly. Band concerts and celebrations were held in Flagler Park throughout the years. Theaters opened for plays, concerts, and movies. The Norton Art Gallery, present-day Norton Museum of Art, opened in the 1940s exhibiting significant works of art. There has always been plenty to occupy one's time.

By August 1894, the Park Cottage, one of the earliest hotels in West Palm Beach, was open for business. It had been the house of O. S. Porter, who sold his property to Henry Flagler's agents in 1893 for the town. Originally located in City Park, Park Cottage was moved near the city wharf in 1895. The hotel, run by Mr. O. Howes, was one of the few open year-round.

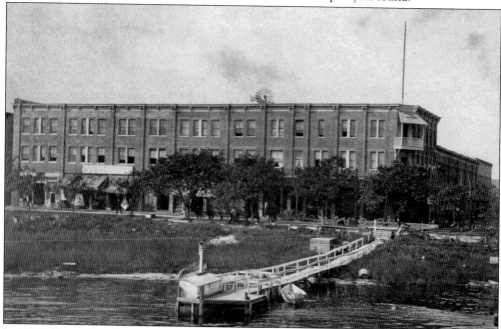

In 1894, George Zapf built the Seminole Hotel, located on the corner of Banyan and Narcissus Streets. At the time, it was one of the largest structures in West Palm Beach. A fire in January 1896 destroyed the wooden building, but it was rebuilt of brick in just two months. It could accommodate 75 guests and cost $2–$3 a day. The Seminole later became the Lake Park Hotel.

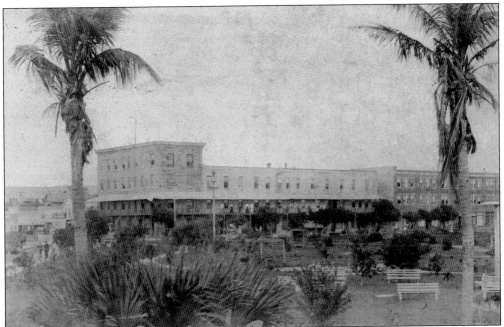

In 1895, J. C. Stowers erected the three-story Hotel Palms on the corner of Clematis and Narcissus Streets. The hotel was a "Temperance hotel" meaning no liquor was served, but guests could get a drink next door at the Seminole Hotel. Between 1896 and 1926, the hotel changed hands several times and was finally razed in 1926. In the 1940s, the Florida Theater, now the Cuillo, was built on the site.

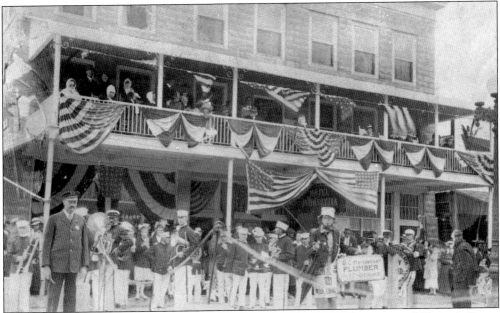

A festive celebration was held in front of the Hotel Poinsettia at the corner of Clematis Street and Poinsettia Avenue. Owner Judge William L. Woodcock of Altoona, Pennsylvania, built the hotel in 1913. It had 75 rooms and a large restaurant and dining area. The hotel's balcony was a prime spot from which to watch the activities on Clematis Street.

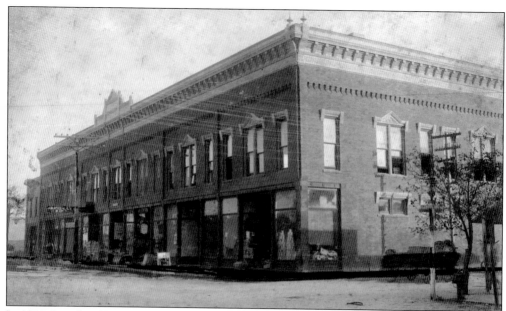

In 1898, Joseph Jefferson, actor, developer, and friend of Henry Flagler, built the Jefferson Hotel, at 223-1/2 Clematis Street at Olive Avenue. The hotel had shops on the ground floor and fronted 150 feet on Clematis Street and 150 feet on Olive Avenue. It was later renovated and renamed the New Jefferson Hotel. It was demolished in the late 1940s to make way for office buildings.

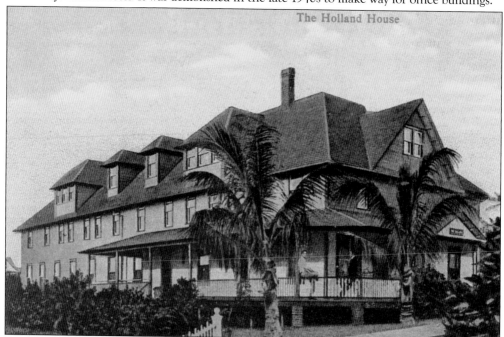

The Holland House, built in 1899 by L. D. Lockwood, was another early hotel in West Palm Beach. It was located at the corner of Narcissus and Evernia Streets and had room for 20 guests. Later improvements increased the number of rooms to accommodate 100 people. Open from November to May, the weekly charge was $10–$20. Holland House was later razed and the larger Pennsylvania Hotel constructed in its place.

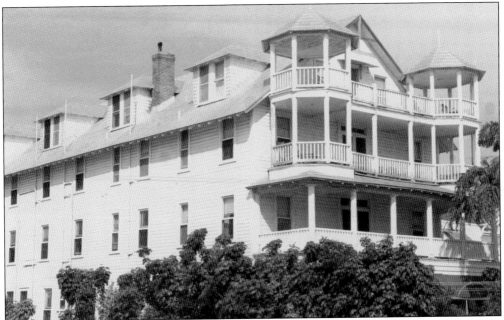

Built about 1907, the Keystone Hotel was located at 423 Datura Street. It had 50 rooms and was four stories high. The hotel restaurant was known for its Sunday afternoon dinner. In July 1968, one of the cupolas was removed for a gazebo in a mini park on Clematis Street. The building was then demolished for the erection of a municipal parking lot.

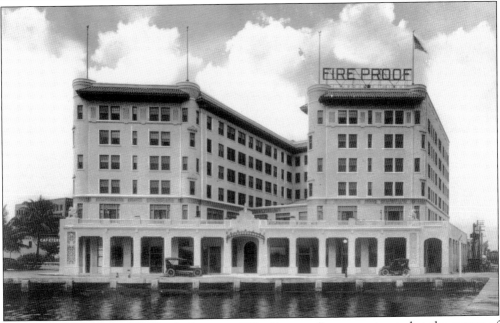

In 1923, the El Verano Hotel, which means "The Summer," was constructed at the corner of Banyan and Flagler Drive and advertised as a "fire proof structure." New owners changed the hotel's name to George Washington in 1930. In 1975, the hotel became the Helen Wilkes Residence Hotel. It was sold in 1996, closed in 1999, and demolished in August 2005 for downtown redevelopment projects.

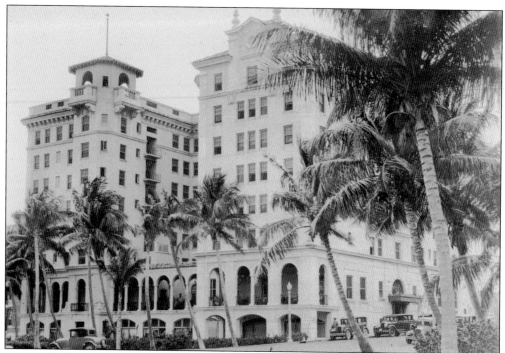

Built in 1925 on the site of the Holland House, the 216-room Pennsylvania Hotel was located at 208 Evernia Street. In 1964, the Carmelite Sisters for the Aged and Infirm bought the hotel for a senior residence hotel. In 1995, it was demolished and rebuilt as the Lourdes–Noreen McKeen Residence and Retirement Community.

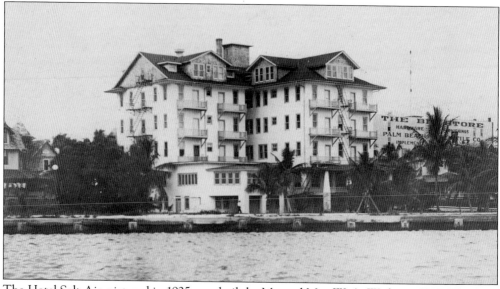

The Hotel Salt Air, pictured in 1925, was built by Mr. and Mrs. W. A. Weihe in 1913. The four-story hotel at the southeast corner of Narcissus and Datura Streets had 74 rooms and overlooked Lake Worth. In the 1950s, the hotel succumbed to developers who replaced it with a Holiday Inn, which in turn was demolished in 1994. In 1996, the Meyer Amphitheater opened on the site of the former hotels.

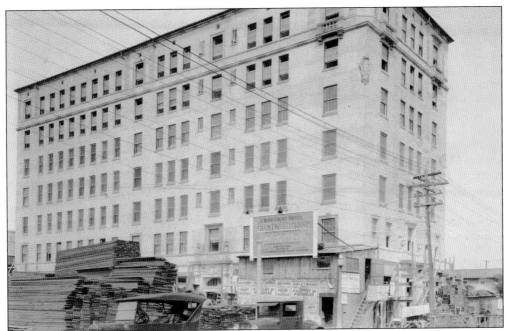

Opened in April 1926, the Dixie Court Hotel was designed by local architects Henry Harvey and Phillips Clarke, whose credits include the Comeau Building and Pennsylvania Hotel. It was seven stories high with 132 rooms, a restaurant, and shops. The hotel was located at the corner of Poinsettia Avenue and 2nd Street and was demolished in 1990 to make way for the newest county courthouse.

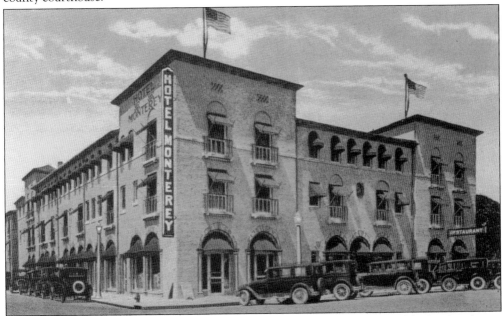

The Hotel Monterey at Clematis Street and Sapodilla Avenue was designed by local architect William Manly King and opened in February 1926. The hotel had 175 rooms and charged $2 to $8 a day. A barbershop, drugstore, and real estate office were on the first floor. Located at 635 Clematis Street, the hotel was razed in 1976 to make way for a state office building.

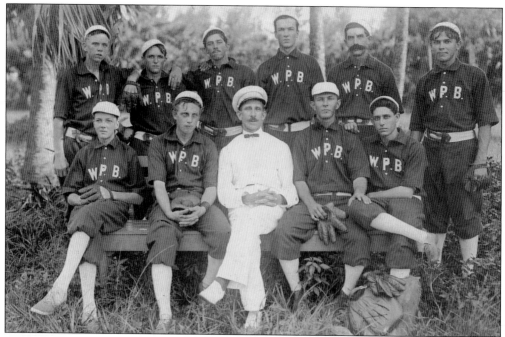

Baseball was popular in 1908 when this local team gathered for this photograph. Several of these men and their families became important to the growth of the city. From left to right are (seated) Jim Devers, K. Wilson Rowan Sr., Marion Gruber, J. Burke Earman, and Harry Sirkin; (standing) William Fremd Jr., Grady Creech, Bob Baker, Edward Devers, Charles Metcalf, and Bert Hiscock.

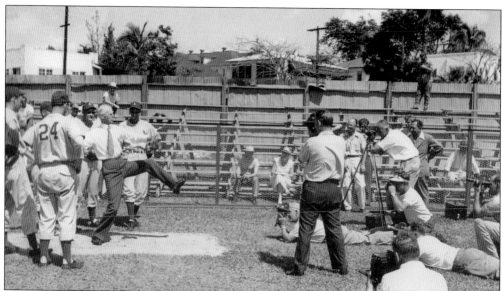

Connie Mack hams it up for the cameras at a press conference in the 1940s. Mack, a legend in baseball history whose career spanned over 60 years, was the owner-manager of the Philadelphia Athletics from 1901 to 1950. From 1945 to 1962, West Palm Beach was the spring training camp for the Athletics. While under Mack's leadership, the Athletics won nine pennants and the World Series five times.

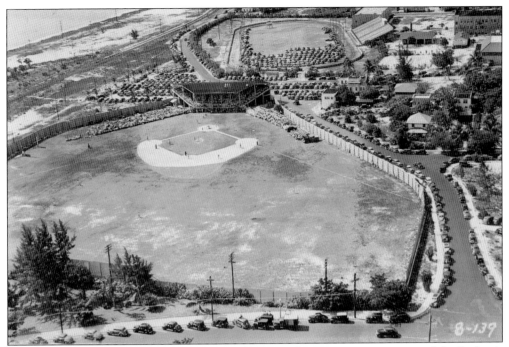

Wright Field opened in 1924 as Municipal Field. It was the spring training camp of the St. Louis Browns (1928–1936) and the Philadelphia Athletics (1945–1962) and home of the West Palm Beach Indians in the early 1940s. The field was renamed Connie Mack Field in honor of the legendary baseball hero in 1952. In 1992, the property became the parking garage for the Kravis Center.

The first golf course in the area opened in Palm Beach in the 1890s. The West Palm Beach Country Club opened in 1921 at Military Trail and Belvedere Road. In 1947, it moved to its present location on Parker Avenue. The subtropical climate allows golfers by the hundreds of thousands to play year-round. In 2006, there were over 160 golf courses in Palm Beach County.

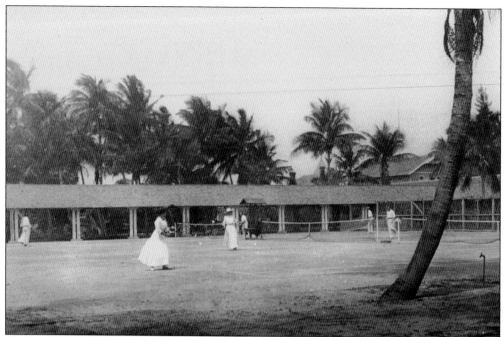

The area's first tennis courts were built in Palm Beach for the wealthy winter visitors. As the sport caught on across America, tennis courts and clubs opened in West Palm Beach and tennis was also added to the school's curriculum. This photograph, taken in the early 20th century, shows women players wearing long dresses and long-sleeve shirts and the men in long pants and shirtsleeves rolled up.

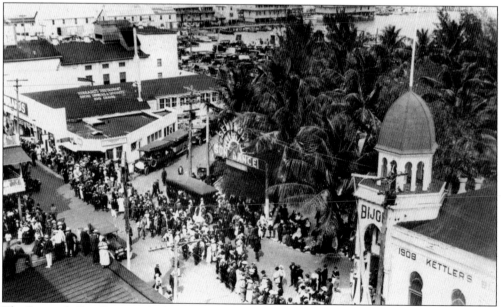

The Seminole Sun Dance, which ran from 1916 to 1950, was held in West Palm Beach as a yearly, three-day event in March to keep tourists here just a bit longer. The present-day Sun Fest is the updated version of the early festival. Fish houses line the docks to the north of City Park, and the Bijou Theater was to the south.

George Graham Currie, a local businessman, wrote many poems and songs about Florida. For the Seminole Sun Dance, he wrote the lyrics of a song that begins with "First natives are we of fair Florida land. . . . Our maids kept its tepees and kindled its flame." Though the Seminole tribe was not the first natives in the state and they did not live in tepees, the song was performed for several years.

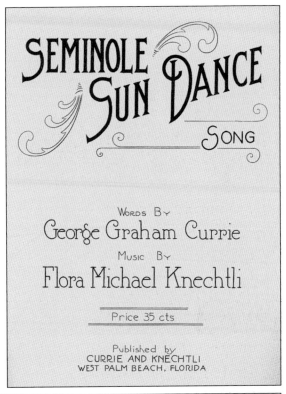

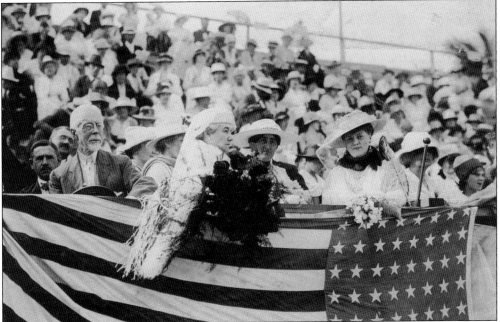

Parades were a major component of the Seminole Sun Dance, and a panel of judges selected the best floats. Shown here during the 1916 festival are Mary Lily Kenan Flagler (left of center and turned to the side), Henry Flagler's widow, and Bula Croker (center), wife of Richard Croker. They were two of the judges for the parade.

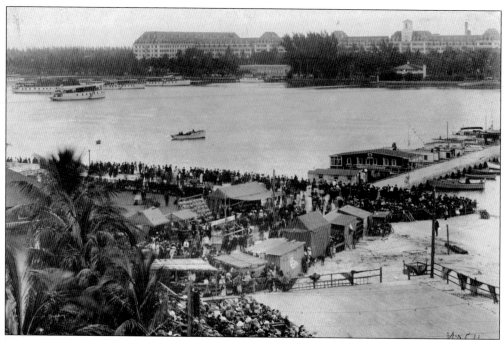

Various vendors and exhibits set up at the City Dock during the Seminole Sun Dance. At many celebrations of this type, vendors sell a variety of goods. The area to the right is part of the staging area and bleachers for the parades and performances. In the background are Lake Worth and the Royal Poinciana Hotel.

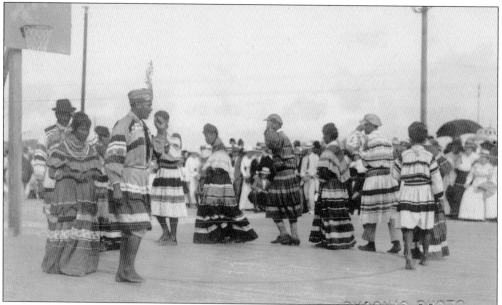

A group of Seminoles perform a ceremonial dance during the Seminole Sun Dance sometime between 1916 and 1920. They wore traditional clothing and performed the dance in their bare feet, except for the man in the center who is wearing shoes. Look closely, and you will notice they are dancing on a basketball court. The basketball hoop is to the left. Basketball was a relatively a new game.

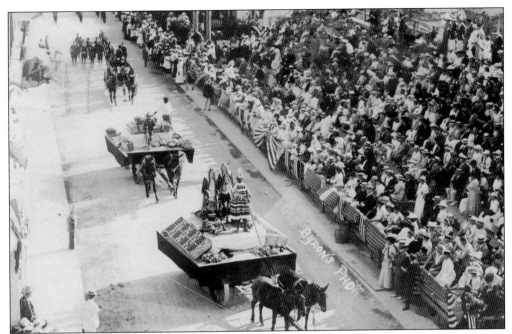

These wagons are displaying the variety of produce grown in Florida at one of the parades during the first Seminole Sun Dance in 1916. A Seminole man is driving the lead wagon, and the two women standing behind him are dressed as Plains Indians, which is not the attire of the Seminole people. Spectators dressed in their Sunday best pack the bleachers to watch the parades.

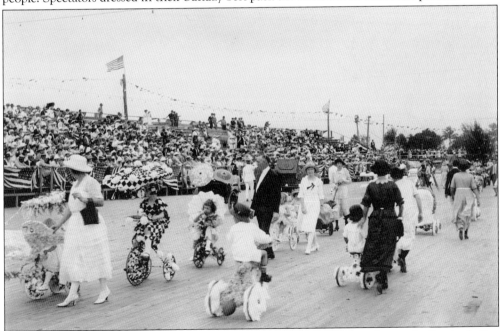

The children's parade took place in front of the bleachers and judges box during the Seminole Sun Dance, sometime between 1916 and 1920. Children dressed in different costumes and decorated their tricycles for the parade. Parents would walk alongside the young children guiding them through the parade. Everyone had the opportunity to dress in his or her finest clothing.

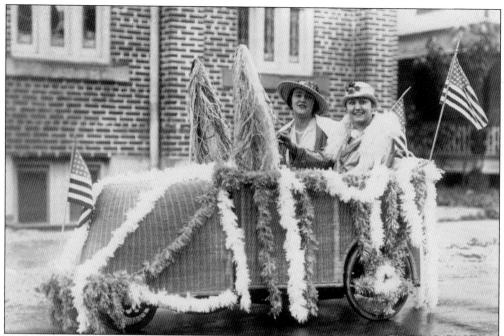

Thelma Barrington, left, and Lola Hausbbeuger Miller smile for the photographer in their decorated parade float while they wait at the First United Methodist Church building at the southwest corner of Datura and Poinsettia Streets about 1916. To standout, the women are driving a wicker three-wheeled vehicle instead of a standard automobile.

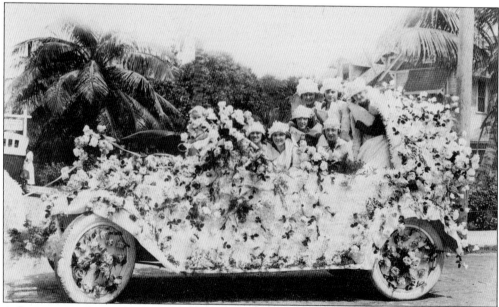

A flower-covered automobile float full of beauties participates in the Seminole Sun Dance Parade sometime between 1916 and 1920. Participants would use their own automobile or would rent one, or if they were fortunate, a car dealer would loan one as an advertisement gimmick for use as a float in the parade. Florists throughout the area were in great demand, as contestants needed numerous flowers to decorate their floats.

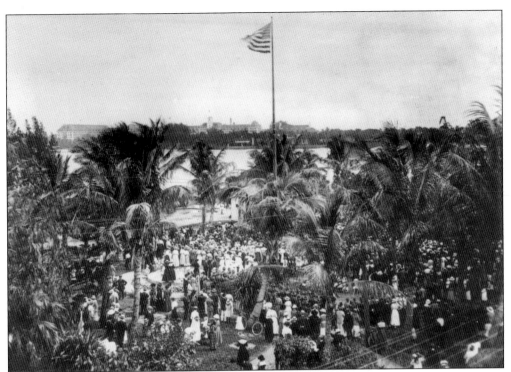

The 1917 Fourth of July celebration took place in Flagler Park. City Park, also known as Flagler Park, was the scene of many holiday celebrations and band concerts. In the background is the Royal Poinciana Hotel and Henry Flagler's Whitehall in Palm Beach.

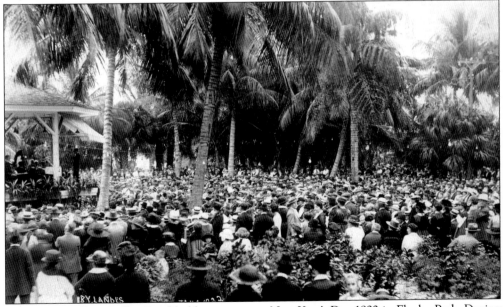

Bachman's Million Dollar Band held a concert on New Year's Day 1922 in Flagler Park. During the Great War, Harold Bachman was leader of the band for the 116th Engineers, and while in France, Gen. Hunter Liggett remarked, "The band was worth a million dollars." After the war, Bachman formed a professional concert band and named it Bachman's Million Dollar Band.

Carl Kettler Jr. opened the Bijou Theater in the Jefferson Building on Clematis Street in October 1908 and eventually moved it to Clematis and Narcissus Streets. In 1923, Kettler razed the Bijou and built the Kettler Theater in honor of his father, Carl Kettler Sr., who once was secretary for actor and businessman Joseph Jefferson. Kettler Jr. also served as a volunteer fireman and city commissioner.

The new, 1,400-seat Kettler Theater opened in 1924 and cost an estimated $500,000 to build. The theater was considered the "finest structure of its kind south of Atlanta." One of the first color talking movies was shown here in 1929. When Kettler later sold the theater, it became the Florida Theater and then the Palms Theater in 1948. A parking lot now occupies the site.

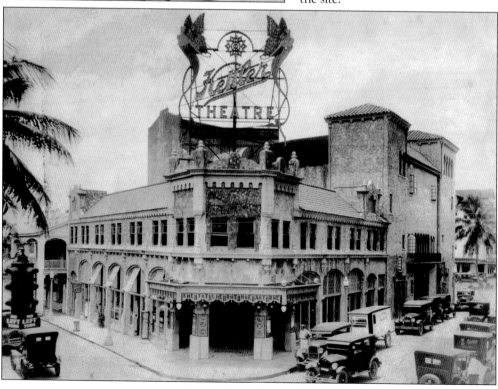

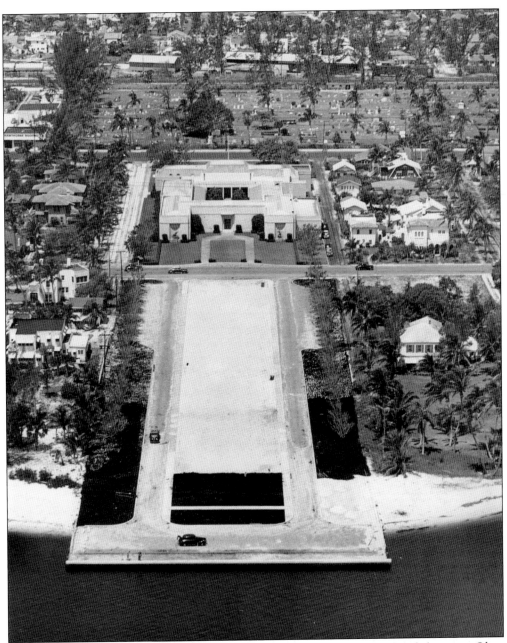

Built on the site of Pioneer Cemetery, the Norton Gallery faces Lake Worth between Olive Avenue and Dixie Highway in the 1940s. After retiring in 1939 from Acme Steel Company in Chicago, Ralph Norton and his wife, Elizabeth, moved to West Palm Beach. They had a large collection of art and decided to build an art museum to share it with the public. They founded Norton Art Gallery in 1941 with nine air-conditioned galleries exhibiting the art the Nortons had collected over many years. The Norton School of Art offered classes in many subjects, including music, drama, and literature. Woodlawn Cemetery is across Dixie Highway, and Flagler Drive had not yet been constructed along the lakeshore. Today the museum is known as the Norton Museum of Art.

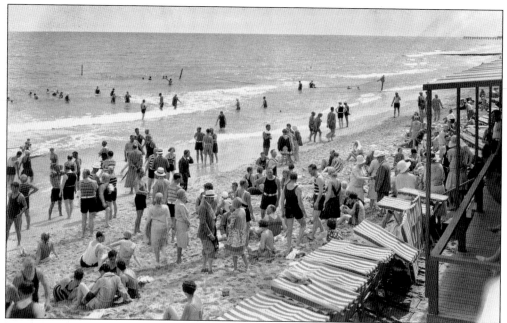

Beachgoers enjoy taking in the sun or a swim in warm Atlantic waters in about 1920. Florida's beaches and climate have always lured locals and tourists to relax and enjoy the sun and surf. West Palm Beach does not have a beach of its own, so beachgoers travel across the lake to Palm Beach for fun in the sun.

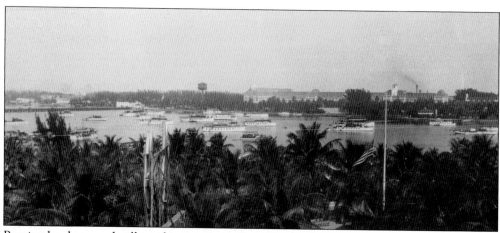

Boating has been and still is a favorite sport of residents and visitors year-round as shown. From the Intracoastal Waterway, which extends the length of Palm Beach County, boaters can access the Atlantic Ocean through any one of four inlets located at Jupiter, Lake Worth, Boynton Beach, and Boca Raton. Shortage of dock space left large yachts at anchor off City Park.

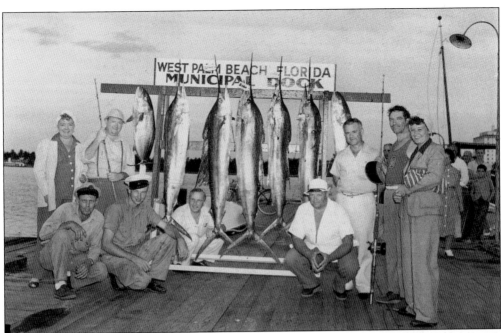

A group of fishermen and women at the West Palm Beach Municipal Dock display their catch of the day. Since the 1870s, sport fishing has been a popular pastime in the Palm Beaches. At the dock, charter boat captains were available for hire to take fishermen deep-sea fishing in the Atlantic Gulf Stream for marlin, sailfish, and other sea fish.

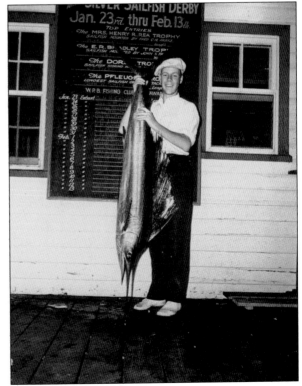

A young man displays his prize catch for the Silver Sailfish Derby in about 1938. The Silver Sailfish Derby inaugurated in 1935 by the West Palm Beach Fishing Club as an annual event offering sportsmen and women some of the finest trophies in the sport. Fishermen from across the country came to West Palm Beach during January and February to participate in the event.

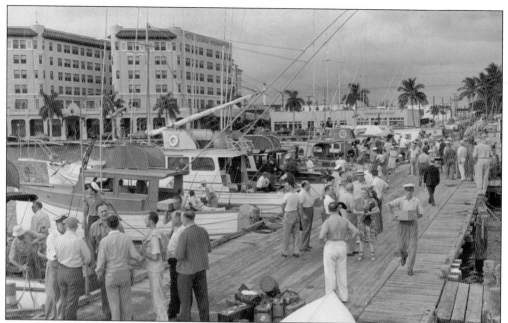

Seen here in 1948 at the City Dock, anglers prepare to board their charter boats for the day's trip to the Gulf Stream as part of the Silver Sailfish Derby. Boat captains probably shuddered to see the pile of luggage fishermen carried. The small sport-fishing boats had limited storage space for belongings. On the left is the Hotel George Washington, formerly the El Verano Hotel.

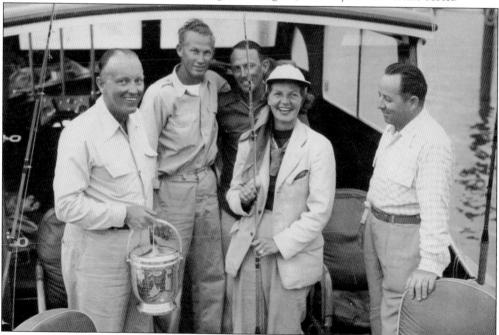

One of the Silver Sailfish Derby awards is presented on a small fishing boat. On board from left to right are George Bass, Jim Holden, Sherrick Hiscock, Mrs. George Bass, and Bob Kleiser in the 1940s. Mrs. Bass holds in her hand one of the fishing poles used to catch marlin. For comfort on the small boats, rattan chairs were provided for the fishermen.

Five

SCHOOLS, CHURCHES, AND HOSPITALS

Early homesteaders on Lake Worth had to travel to Titusville by boat for medical care and most relied on home remedies or tended to themselves. In 1881, the Lake Worth community recruited Dr. Richard Potter who had been living in Biscayne Bay since 1874. Dr. Potter would often travel Lake Worth by boat to visit his patients and at times he would walk the beach, sometimes 15 miles, if he could not reach them by boat.

The Board of Education in Dade County divided the county into districts in 1885. Dade County School District #1 was established from St. Lucie River to the north and south to Hillsborough River. The board proceeded to acquire land and begin the process of constructing schools. The first school on Lake Worth was opened in March 1886 on what is now Palm Beach. The first school in West Palm Beach was established in 1894.

The first organized church services on Lake Worth were held in 1889 when Rev. Joseph Mulford from New York began holding services at the schoolhouse. Once Flagler established West Palm Beach, he then donated money and property to establish churches, schools, and later a cemetery. Different religious denominations soon established their own churches and synagogues in the city.

In 1893, Dr. Potter built a residence-office near the foot of present Gardenia Street, and within four years there were 17 killings, one lynching, and shootings, which were commonplace, attributed mostly to Flagler's construction workers. Other doctors followed, but it was not until 1914 that Emergency Hospital was built with five beds on 3rd Street. Pine Ridge Hospital, established at 5th Street and Division Avenue in 1916, was the only hospital in the area for black community. Good Samaritan Hospital replaced Emergency Hospital in 1920. The new hospital with 35 beds was located at 12th Street and the lakefront. In 1939, St. Mary's Hospital opened on the hill just north of 45th Street with 50 beds.

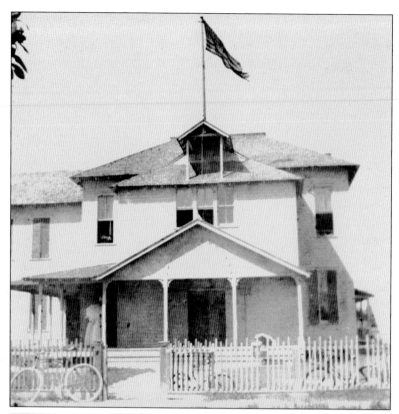

On September 19, 1894, the Board of Public Instruction of Dade County approved construction of the first school in West Palm Beach at the southwest corner of Clematis and Poinsettia Avenue. The board appropriated $600, and Flagler donated $1,000 and the deed to a suitable lot. Central School was built in 1908, and this building was used as the first county courthouse when Palm Beach County was created in 1909.

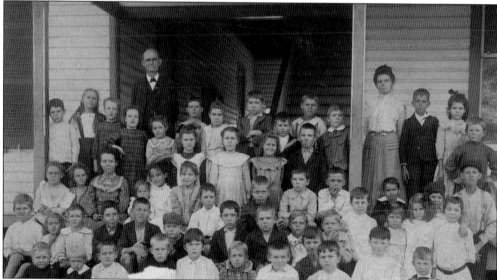

This class photograph was taken shortly before the new Central School opened in 1908. The adults at top are Jack Baker and Miss Amy Lee Harris, the teacher. Some of the students, not in any order, are Gertrude Hays Ahrens, Elmer Cook, Curtis Chillingworth, Elmer Cook, Kathryn DaCamara Morrison, Ethel Hardwick, Ed McKenna, Paul Williamson, Don Lainhart, Alvin Crow, Leslie Darling, Tye Lett, Warren Turpin, Paul Majewski, Stetson Sproul, and Bernice Savage Bowery.

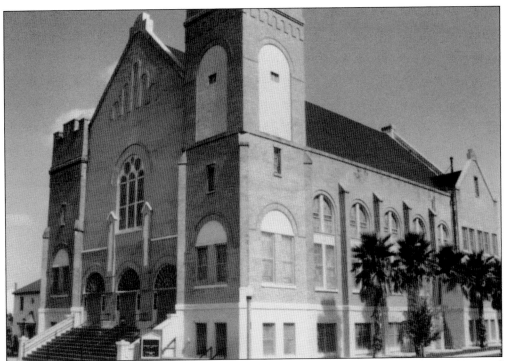

The first Tabernacle Missionary Baptist Church was built on the corner of Clematis Street and Tamarind Avenue and housed the first school for black children in West Palm Beach, with 74 children enrolled by October 1894. This church was destroyed in a 1902 hurricane, and a new church was built the following year. The church has been located at 8th Street and Division Avenue since 1925.

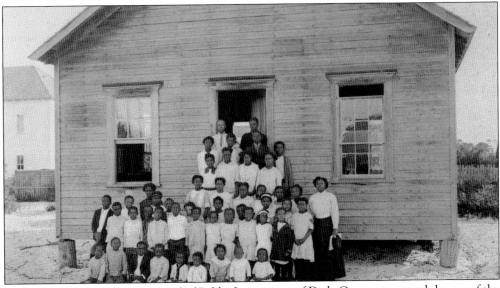

On September 19, 1894, the Board of Public Instruction of Dade County approved the use of the Tabernacle Missionary Baptist Church as a school for the black community. Attendance grew, and in 1896, construction began on their first school building, pictured here at the corner of Datura Street and Tamarind Avenue, with classes commencing in the "off season" in 1897.

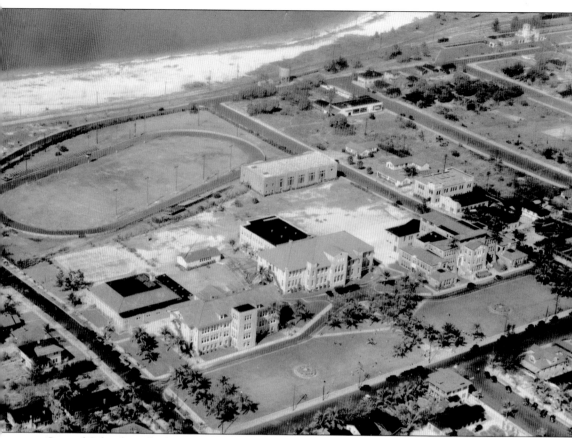

Central School was built in 1908 "on the hill" overlooking the east side of Clear Lake at Hibiscus Street and Georgia Avenue. The 18-acre location was then considered "the wilderness west of town," but by 1915, a larger school was needed, and Palm Beach High School was built just south of the original Central School, which then became Central Elementary School. A much-larger school was needed by 1922, and a third Palm Beach High School was built south of the second, which then became Central Junior High School. Tamarind Avenue and the Sea Board Air Line Railway, whose station, presently houses the Tri-Rail station, can be seen in the top right-hand corner of this 1930s photograph. The Alexander W. Dreyfoos Jr. School of the Arts is now located on the site of the old Palm Beach High School.

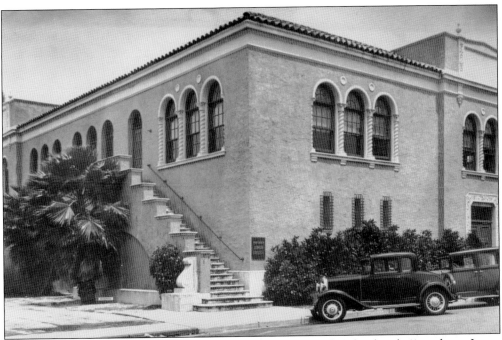

In 1933, Palm Beach Junior College opened at Palm Beach High School with 41 students. It was the first public junior college in Florida. Howell L. Watkins and Joseph Youngblood worked to establish the college to provide additional training for high-school graduates during the Depression. The original building, listed on the National Register of Historic Places, is once again being used by Palm Beach Community College.

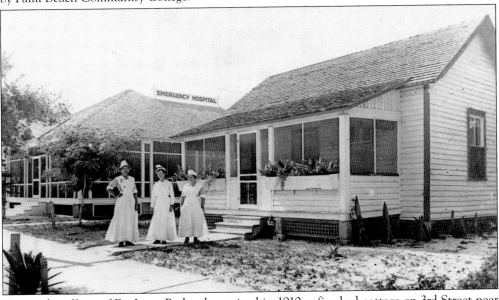

Due to the efforts of Dr. Leon Peek, who arrived in 1910, a five-bed cottage on 3rd Street near the Florida East Coast Railroad was the only emergency hospital for patients when it opened in 1914. Alice Clark, a nurse, is pictured standing on the left with two unidentified women. It had an operating room, nurse's room, kitchen, bathroom, and a tent in the back for the nurse or housekeeper.

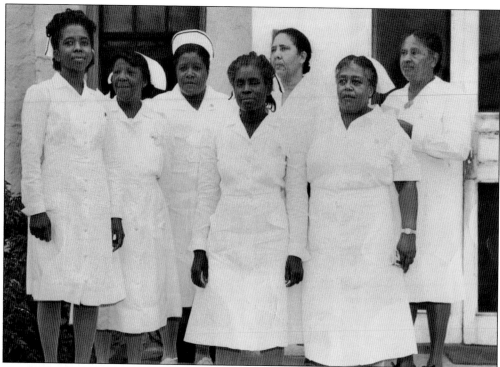

Pine Ridge Hospital, established at 5th Street and Division Avenue on April 15, 1916, was the only hospital available to the black community. It had a well-trained medical staff but was poorly equipped with an elevator pulled up by a rope. Pine Ridge Hospital nurses are pictured here about 1950, from left to right: Marietta Shufford, Mrs. Lefleur, unidentified, Mrs. Pooler, Charlie Mae Cohen Smith, Marie Stokes, and Nurse Brown.

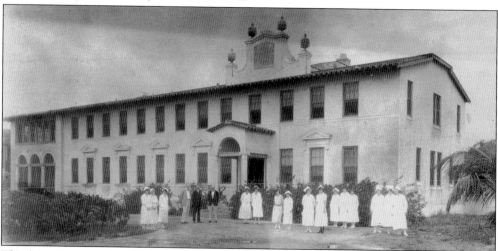

The first permanent hospital in West Palm Beach, Good Samaritan Hospital opened May 19, 1920, at 12th Street and the lakefront with 35 beds. Pictured in 1924 from left to right are Harley Inez Williams, unidentified, Eula R. Powell, Dr. Dawson, Dr. William Ernest Van Landingham, Dr. Powell, unidentified, Eunice Walker, Annette Shackelford, Margaret Turrentine, Marjorie Hopkins, Elizabeth Hite, Hazel Wesson, Miss Ryan, Louise Osborne, Kitty Baker, Miriam Fuller Taylor, and Era Nasmarthy.

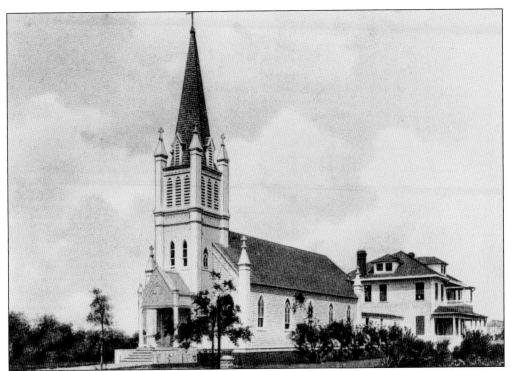

Organized in 1892, St. Ann's Catholic Church was constructed in 1895 on the corner of Rosemary Avenue and Datura Street and was moved in 1902. The Historic District of St. Ann's, five buildings, is on the east side of North Olive between 3rd and 4th Streets. In 1912, the present church was constructed, and in 1923, St. Ann's School began holding classes.

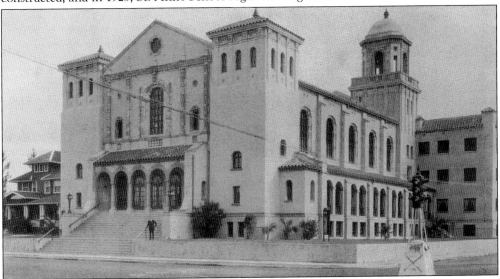

The First United Methodist Church was established in 1892, and Rev. J. R. Walker built the first wooden chapel in 1898 on the corner of Datura Street and Poinsettia, now Dixie Highway. The second church was built about 1914 at Hibiscus Avenue and South Rosemary, now Florida Avenue. The third building, pictured here, was built in 1925 and is currently the site of the Harriet Himmel Gilman Theater.

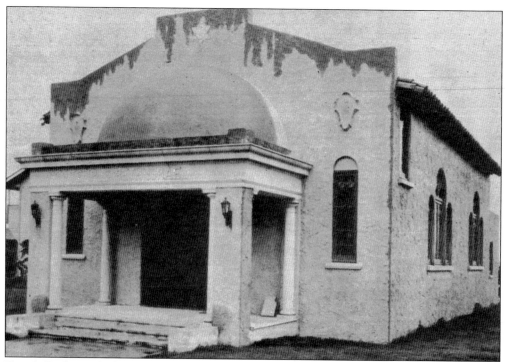

Temple Beth Israel, the first Jewish temple in West Palm Beach, was organized with six families in October 1923 under Max Sirkin, the first president. By the time the economy collapsed in the late 1920s, Temple Beth Israel had a congregation consisting of over 45 families. Many were local businesses owners, including Simon Argintar, owner of Cy's Men Store, who was president of the temple during this period.

St. Mary's Hospital opened on the hill just north of 45th Street in 1939 with 50 beds. In 1948, the Board of Trustees of St. Mary's Hospital assumed responsibility of operating Pine Ridge Hospital. Considered a voluntary hospital, St. Mary's Hospital was sponsored by the Franciscan Sisters of Allegany, New York, from 1939 until the 1990s.

Six

HURRICANES

Hurricanes are a seasonal natural phenomenon that affect the United States's Eastern Seaboard and the Gulf of Mexico coastline. These storms can bring rain and winds that can cause little or no damage or be devastating to the communities in these areas. In July and September 1926, hurricanes hit south Florida causing widespread destruction. The September storm brought serious damage to Miami, caused flooding in Moorehaven on the south coast of Lake Okeechobee, and affected West Palm Beach. The most devastating hurricane to strike West Palm Beach and Palm Beach County was the 1928 hurricane, which caused widespread destruction and over 3,000 deaths in the county. Three hurricanes in the late 1940s brought serious floods and wind damage to West Palm Beach. Regardless of the damage caused by these storms, the city has always recovered and has continued to grow and develop.

The
1928
HURRICANE
In Florida

112 Amazing Pictures

Showing Scenes During and Immediately After the Storm; Photographs Taken at Belle Glade, South Bay, Throughout the Everglades, the Palm Beaches and Lower East Coast

Complete History

GIVING A DESCRIPTIVE STORY OF THE STORM FROM ITS START; STATISTICS; DEATH LIST; AND ALL INFORMATION OF INTEREST

- $1 -

On Sunday afternoon, September 16, 1928, a massive Category Four hurricane roared through Palm Beach County. The most deadly hurricane on record, winds were reported to have been 160 miles per hour at Canal Point, causing the dike around Lake Okeechobee to break and flood the Glades area, killing at least 3,000 people. According to the Florida Health Department, 11 deaths occurred in West Palm Beach. The hurricane caused about $75 million in damage in the county with $13 million of that in West Palm Beach. This booklet was printed within days of the hurricane to help raise money for hurricane victim relief. Tampa's mayor told northern newspapers that the hurricane was greatly exaggerated, which was true for Tampa but not for southeast Florida. Palm Beach County officials were hindered by these claims, making it more difficult to get desperately needed aid.

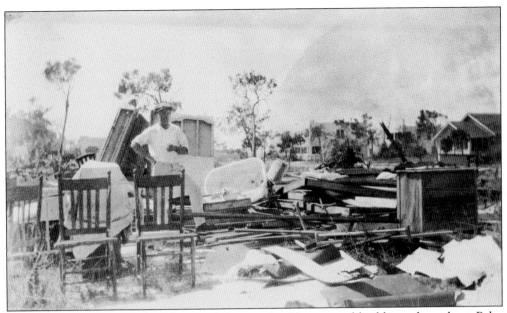

Hurricane winds damaged or destroyed thousands of homes and buildings throughout Palm Beach County. This man, thought to be Walter Mollineaux, stands amid the wreckage of his house at 619 53th Street in West Palm Beach with what little was left, and according to records, he rebuilt his house by 1930.

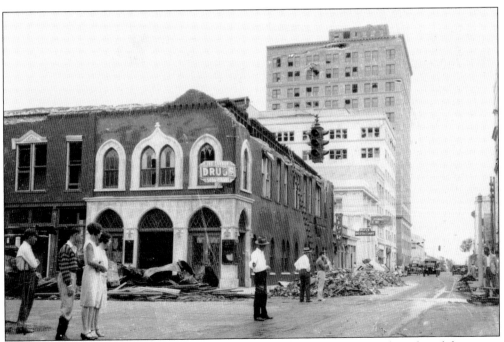

Looking south along Dixie Highway, mounds of debris are piled up on the sides of the street. Winds damaged the roof and south wall of the Corner Drug Store in the foreground. Windows were blown out of the 14-story Harvey Building. Ironically, with all the damage sustained by high winds, the traffic light at the intersection was not blown away.

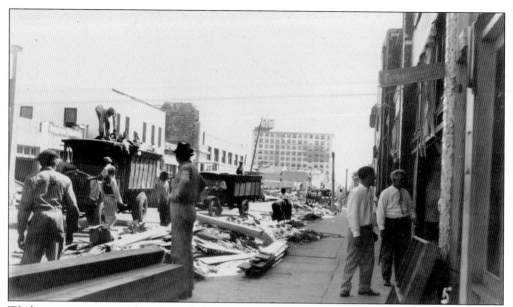

Work crews were out within days of the storm, cleaning up and picking up piles of debris along on Clematis Street as people began to put their lives back together. The one-story building to the left and just behind the lead dump truck is Broadway Tailoring Company, located at 517 Clematis Street.

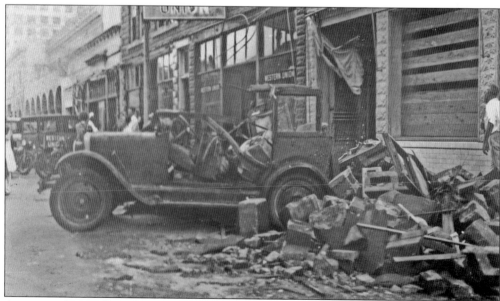

A car was damaged by falling debris in front of the Federal Bakery at 207 Clematis Street. To the left is Western Union at 209 Clematis. This picture was taken the day after the hurricane, September 17, 1928, as people began to take stock of the damage.

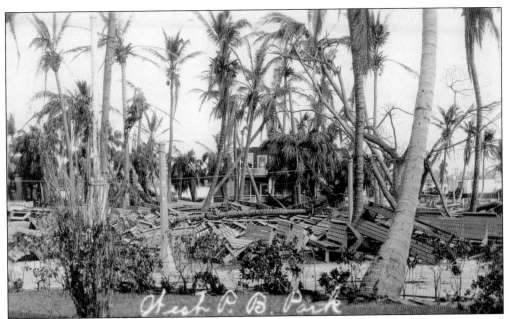

The hurricane left major wreckage in City Park at the foot of Clematis Street. The winds knocked over palm trees and destroyed the benches, turning them into splinters. The structure in the center had its roof torn off as the hurricane passed over West Palm Beach.

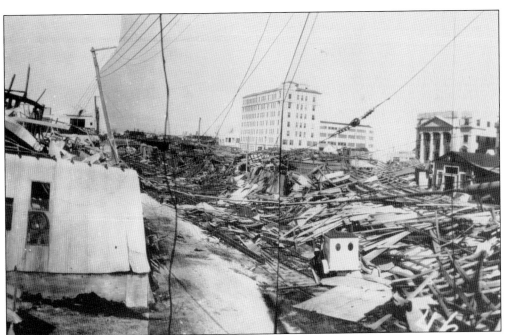

Looking northwest from Olive Avenue, destruction from the hurricane can be seen in downtown West Palm Beach. In the center is what is left of Dade Lumber Company at 314 2nd Street. To the right is the county courthouse at Dixie and 2nd Street, where many residents took refuge during the storm. The tall building in the center is the Dixie Court Hotel, which had many windows blown out.

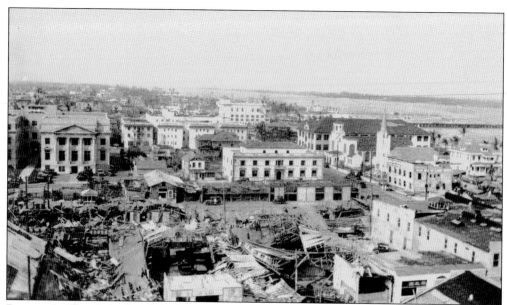

Damage in West Palm Beach looking north from the Comeau Building. To the right are Taylor Auto Top and Body Works and St. Ann's Church. The Florida East Coast Railroad bridge is in the upper right. To the upper left is the 1927 county courthouse addition, which was a mirror image of the 1916 courthouse.

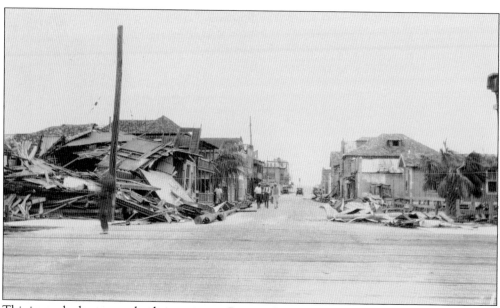

This image looks west at the destruction on Banyan Street, west of the Florida East Coast (FEC) railroad tracks. The huge pile of debris at the left was once a business or a home.

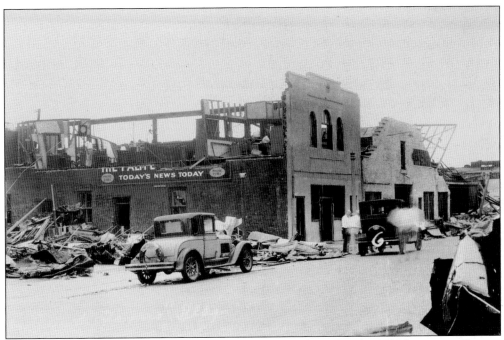

The *Palm Beach Times* building at 329 1st Street was roofless after the 1928 hurricane. Despite the damage, a short edition of the paper was published the day after the hurricane. The following year, the newspaper moved to 26 Fagan Arcade at 325 Clematis Street.

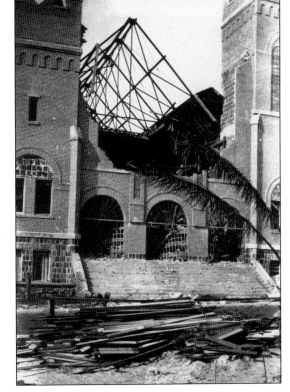

The hurricane damage to the Tabernacle Missionary Baptist Church, located at the corner of 8th Street and Division Avenue, included the central part of the roof and the front facade caving in during the storm. High winds and flying debris bent the metal grillwork at the front entrances, and bricks from the facade littered the steps. The church was rebuilt but sustained further damage during the hurricanes of 2004–2005.

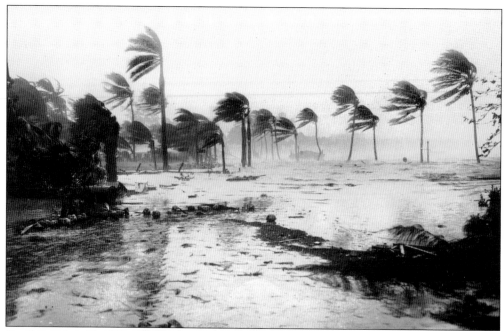

On September 17, 1947, a Category Four hurricane came ashore at Pompano Beach with winds of 155 miles per hour. Winds of 100 miles per hour reached West Palm Beach just before noon. This photograph shows palm trees swaying at the height of the storm as waters from Lake Worth flowed over Flagler Drive in front of Holy Trinity Episcopal Church. This hurricane caused over 50 deaths and $704 million in damages statewide.

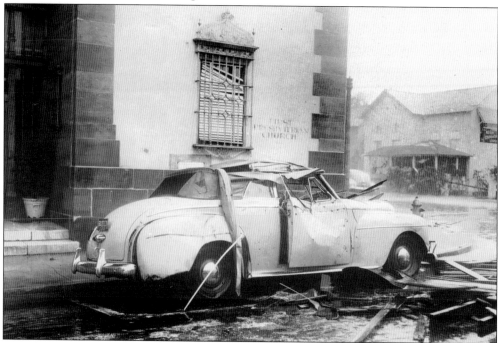

Parked next to the First Presbyterian Church at 301 South Olive Avenue in downtown West Palm Beach, this convertible automobile was damaged by a flying roof from a nearby building.

A photographer discovered this unusual water stain at Babcock's Furniture Store located at 512 Clematis Street. As if by design, Mother Nature left what looks like a map of the southeastern United States on a wall in the store.

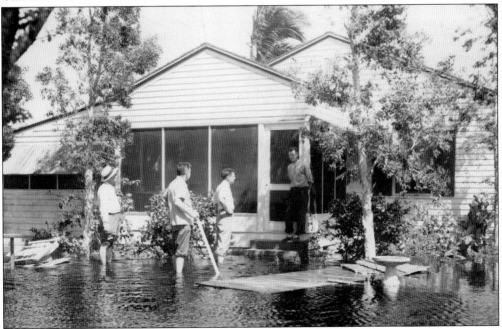

City health inspectors, from left to right, Allie B. Hartsfield, Lonnie C. Merritt, and Dr. Paul Rainey, talk with Peter Wundlich at his home at 2030 Delphia Avenue just west of the National Guard Armory. The inspectors offered to move residents whose homes were flooded by overflowing waters from the Stub Canal.

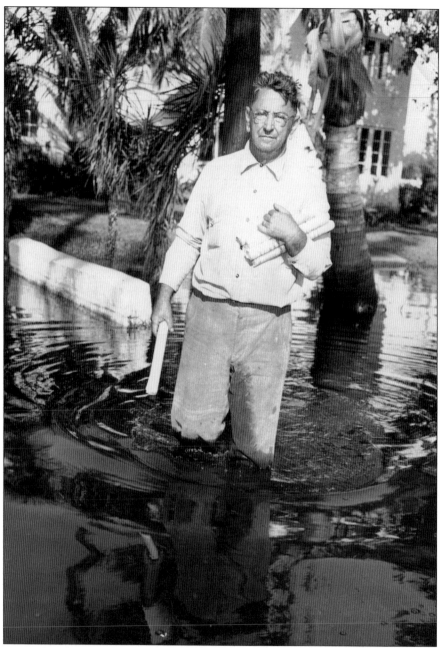

A Category One hurricane crossed south Florida from southwest to northeast October 9–16, 1947. It moved through Palm Beach County into the Atlantic, where it split into two storms. The hurricane was also used as an experiment. It was the first one to be seeded with dry ice or silver iodide. The purpose was to cool the hurricane, thereby reducing its strength. It did not work. The hurricane caused one death, about $20 million in damages, and the worst flooding to date in south Florida. It led to the formation of the Central and Southern Flood Control District that later became the South Florida Water Management District. Charles Richardson, a 19-year carrier with the *Palm Beach Post-Times,* was not deterred from his nearly 700 daily deliveries as he waded through floodwaters left by the hurricane.

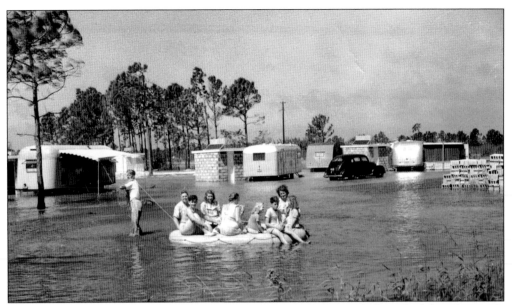

A young man makes the best of difficult circumstances by giving kids and adults a boat ride in the hurricane-created shallow lake. The flooded trailer park was located in the Four Points section of Military Trail.

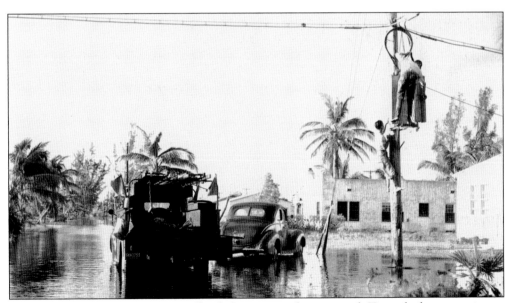

Even though Garden Avenue was flooded, repair work continued. Two telephone repairmen clung to a telephone pole as they attempted to restore phone service to residents. The man on the bottom is barefoot.

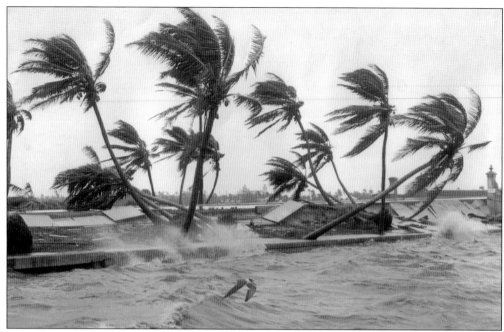

On August 26, 1949, a Category Three hurricane, following a track similar to the Great Hurricane of 1928, struck Palm Beach County, causing about $4 million in damages. The following morning, winds were still blowing hard as the palm trees swayed at the West Palm Beach entrance to Royal Park Bridge. The sea gull was showing his mettle as he made his way into the wind.

The roof of the Civil Aviation Authority's communications station at the airport began leaking at the height of the storm. Trying to keep the equipment dry from left to right are V. M. Sczymansk, A. V. Baird (in charge of the station), E. S. Fryzal, and at the radio, N. D. Turner. A broom was used to prop up the ceiling while water poured into a bucket.

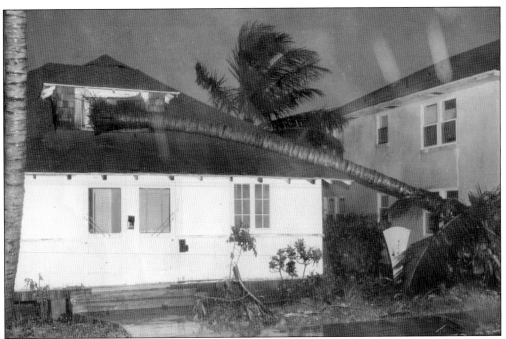

As hurricane winds whipped through West Palm Beach in August 1949, they left a present for the owner of this house on Lakeview Avenue. Winds uprooted the palm tree and planted it in the second-story window. It is interesting to note that the windows on the houses in the picture do not have plywood or hurricane shutters protecting them from the wind and flying debris.

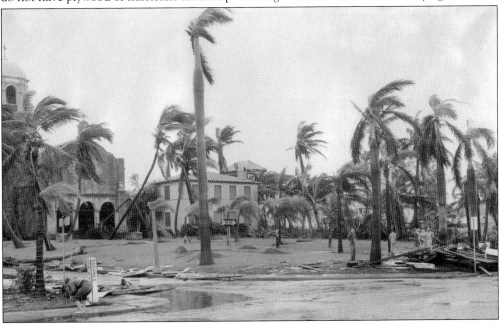

Residents are out surveying the damage and debris in front of Holy Trinity Episcopal Church after the August 1949 hurricane. The church, which overlooks Lake Worth, was designed by Henry Harvey and was one of his favorite buildings. Today Holy Trinity sits in the shadow of the Phillips Point Office Building.

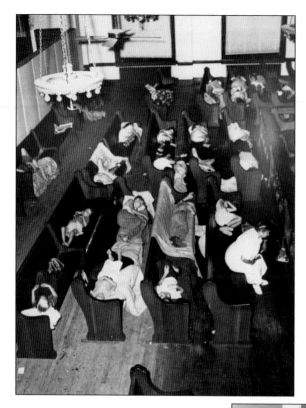

Residents taking refuge from a hurricane turn courtroom benches into makeshift beds in the Palm Beach County Courthouse. People made do sitting or sleeping on the hallway floors during the storm. The Red Cross set up in one of the halls, distributing food and drinks to those waiting out the hurricane. The building was used as a shelter during several storms, including the horrific September 16, 1928, hurricane.

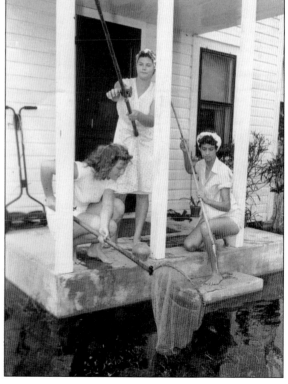

Hurricane floodwaters don't seem to dampen these women's spirits as they attempt to make the best of a trying situation. These ladies ham it up for the photographer from the front porch of their house, which is surrounded by floodwaters following a hurricane in the late 1940s.

Seven

TRANSPORTATION

The first settlers arriving in the remote Lake Worth region had to come by boat. Water transport was a necessity for travel and for shipment of goods. Later canals dug from Lake Okeechobee to the east coast were used, not only for drainage of farmland and flood control, but also as a water highway for agricultural products shipped from the Glades area to West Palm Beach and then on to points across the United States.

As land transportation systems were developed, the boat, while still used for delivery of goods and the transport of people, became a sport. The arrival of the railroad in West Palm Beach in 1894 changed everything. It was more efficient and faster for personal travel and for shipment of goods to and from the area. While goods and people were transported by rail and water, human-powered travel appeared in the forms of wheelchairs and bicycles.

By the 1910s, the first automobiles were becoming commonplace on city streets. Roadway systems were primitive at first, dirt roads followed by crushed shell excavated from local Native American shell mounds, or middens. Shell roads gave way to crushed rock and oil and finally to asphalt and concrete.

The first airplane to appear in Palm Beach County made its debut as a real estate gimmick in 1911. Following were seaplane bases established on Lake Worth. Small airfields along Belvedere Road were opened and maintained for small sport aircraft, airmail service, and limited passenger service. A larger airport, constructed between Belvedere Road and Southern Boulevard, became the present-day Palm Beach International Airport.

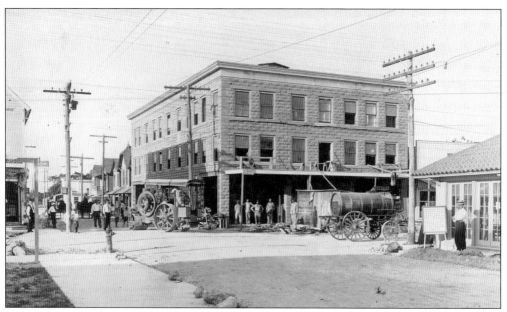

Good roads are essential for all modes of land transportation system. In this view of the intersection of Clematis and Poinsettia Streets, a steamroller is in the process of smoothing out the rock roadway about 1912. The roads in West Palm Beach progressed from dirt to shell, rock, asphalt, and concrete. To the right is George E. Andrews's real estate office and at the extreme left is Doe's Drug Store.

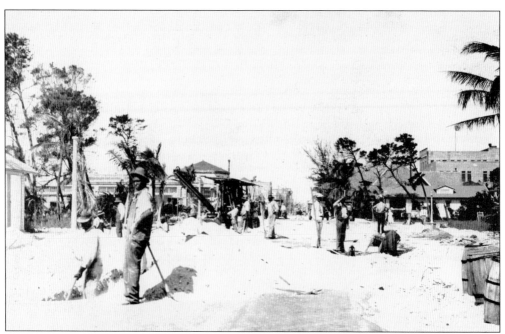

Workers are laying new water pipe and grading the road for new asphalt pavement on Dixie Highway in 1926. In 1924, the highway from Jacksonville to Miami was 381 miles long and had various types of pavement such as brick and clay, shell, asphalt, and oiled rock. The section through West Palm Beach was oiled rock. Two years later, it was repaved with asphalt.

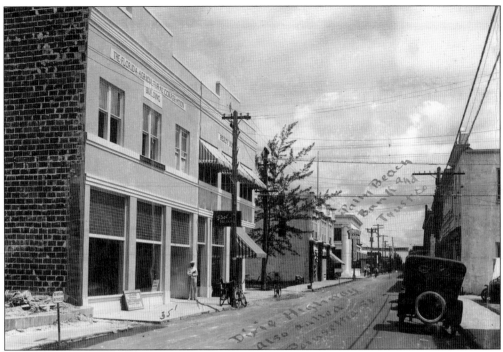

This view shows Dixie Highway through the center of West Palm Beach after repaving the roadway in the 1920s. In the distance are Elbre's Pharmacy, Palm Beach Bank and Trust, and a banner that reads "Republican Headquarters, Palm Beach County."

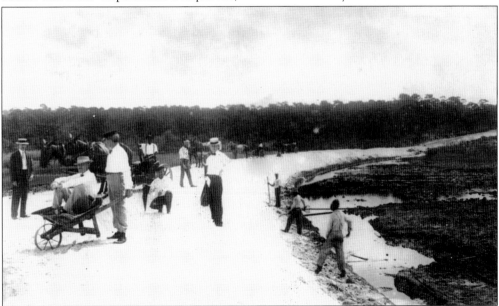

Workers building Okeechobee Road (Boulevard) at the south end of Clear Lake raise the roadbed several feet above the surrounding swampy landscape, so the road does not flood, about 1917. The road was to extend to Lake Okeechobee but went only as far as Loxahatchee Groves. In 1926, Okeechobee Road was paved only as far as Military Trail. Today it ends at Seminole Pratt Whitney Road.

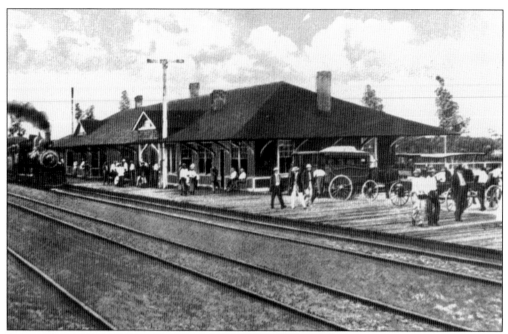

A new West Palm Beach FEC passenger depot was constructed in 1904, replacing the first train station located between Datura and Evernia Streets. The freight station was at the lakefront on a spur near the El Verano Hotel. In the late 1960s, the passenger depot was demolished to make way for development.

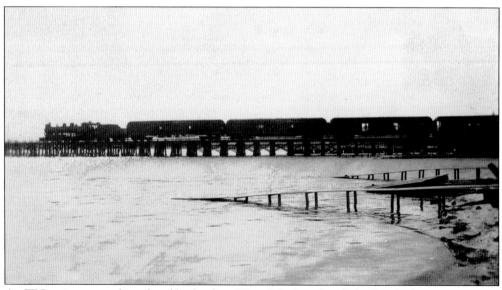

An FEC train crosses the railroad bridge from West Palm Beach to Palm Beach about 1918. Trains were still crossing the bridge in the 1930s and 1940s. The ramps in the foreground are from the seaplane base located just north of the bridge in West Palm Beach. A railroad bridge once crossed from 1st Street to the south side of the Royal Poinciana Hotel beside Flagler's house.

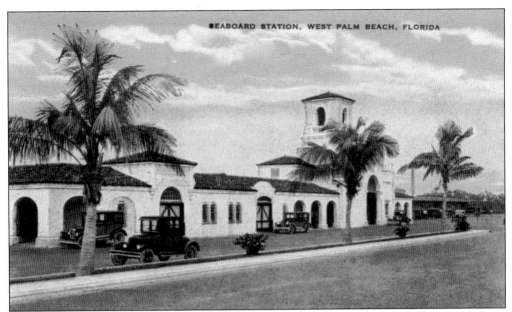

The Seaboard Air Line Railway first operated in north and west Florida before coming to West Palm Beach. The president of the company, S. Davies Warfield, constructed a new line into West Palm Beach arriving January 25, 1925. The arrival of this railroad may have competed with the FEC railroad. The Seaboard Air Line station was, and still is, located at Tamarind and Banyan Boulevards.

The Spanish Revival Seaboard Air Line Railway Station in West Palm Beach was built at Tamarind and Banyan Boulevards in 1925. The local architectural firm of Harvey and Clark designed the $50,000 station. Today it is still in use by AMTRAK railway and by Tri-Rail.

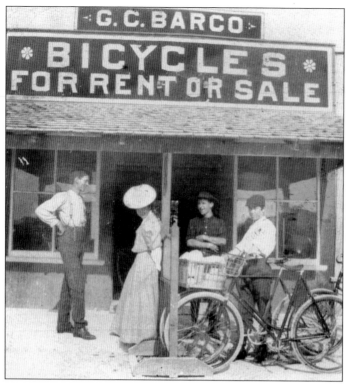

A delivery boy with his deliveries in the basket makes his rounds. The bicycle shop, at Clematis and Poinsettia Streets, belonged to George C. Barco, who opened the shop in 1905. Bicycles, called wheels, were once a favorite mode of transportation in the city. Before the police used cars, officers used bicycles as their patrol vehicles. In 1919, the local newspaper estimated that there were 4,300 bikes in use daily.

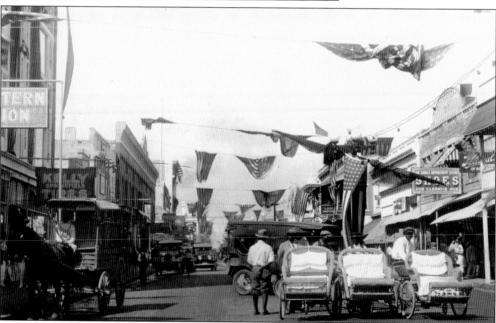

Three different modes of transportation are parked on Clematis Street about 1921. The wheelchairs at the right were a common form of local travel in the Palm Beaches. These were a three-wheeled rickshaw type of manpowered vehicle. Wheelchairs had a wicker seat in the front for passengers and a bike attached to the back for propulsion. Many of the wheelchair owners and operators were local African Americans.

Shown here is the dredging of the West Palm Beach Canal in 1916. At left is the dredge and on the right is a worker's support cabin. The canal, also known as the C-51 canal, was completed in 1917 and extends from east to west along Southern Boulevard from West Palm Beach to Canal Point. It was originally dug to drain the Everglades for farmland and to lower Lake Okeechobee.

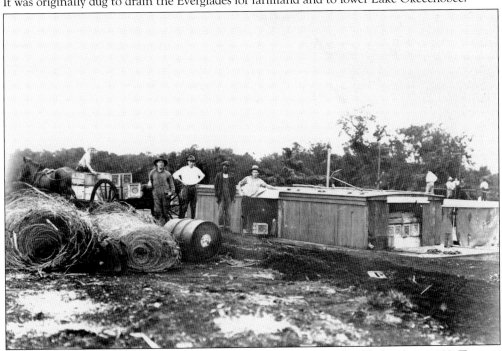

A barge unloads its crates at the Stub Canal before returning to the Glades about 1920. To open the Glades area of the county to West Palm Beach, a stub canal was dug from the West Palm Beach Canal to a basin in today's Howard Park, which opened on May 27, 1918. It made it easy for farmers to transport their produce to West Palm Beach for shipment to markets across the United States by trains.

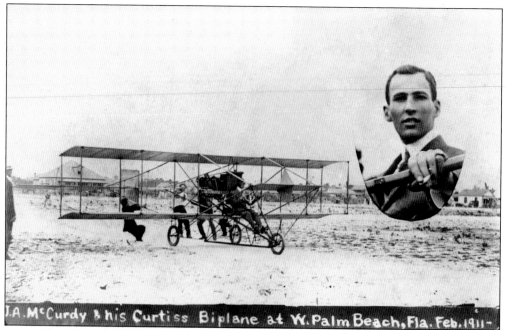

J.A. McCurdy & his Curtiss Biplane at W. Palm Beach, Fla. Feb. 1911-

As a real estate gimmick, local developer George Graham Currie brought Curtiss Aircraft test pilot James A. McCurdy to West Palm Beach in February 1911. Seen here, McCurdy gets ready to take off in his Curtiss biplane from a field in West Palm Beach. This was the first airplane flight to take place in Palm Beach County.

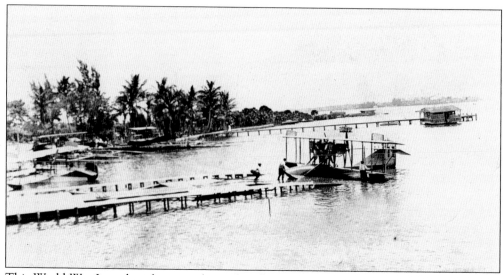

This World War I seaplane base was located in front of today's Rosarian Academy on Flagler Drive in West Palm Beach. The picture was taken looking north from the FEC railroad bridge where the Flagler Memorial Bridge now crosses Lake Worth.

This is the flight station of American Trans Oceanic Company at Roosevelt Seaplane Base just north of the Flagler Memorial Bridge in January 1920. The base was considered an international airport. Shown on the "runways" are two Curtiss Seagulls and "The Big Fish," a converted H16 seaplane. During World War I, the navy used the H16 for anti-submarine patrols along the East Coast and in Europe.

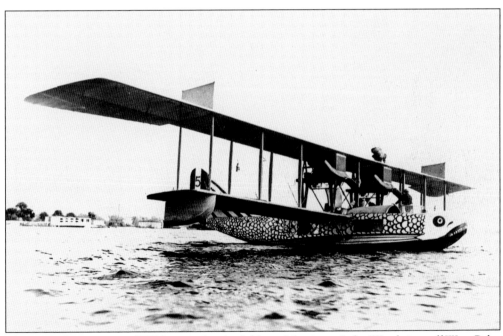

The Big Fish, a converted H16 painted to look like a fish, sits at Lake Worth just off West Palm Beach in 1920. This flying boat was well known from New York to Havana and Nassau in the early 1920s. The oddly painted aircraft was part of the American Trans Oceanic Company's fleet.

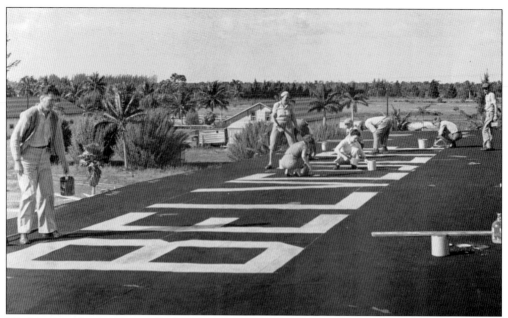

Workers were busy painting the hangar roof at Belvedere Airport in the 1930s. In 1927, Murray Carmichael constructed Carmichael Field, a small airfield on 200 acres of his property on Belvedere Road. By 1932, it was called Belvedere Field and was one of two airports in West Palm Beach. The airport, located between Belvedere Country Club and Palm Beach Kennel Club, was gone by 1955.

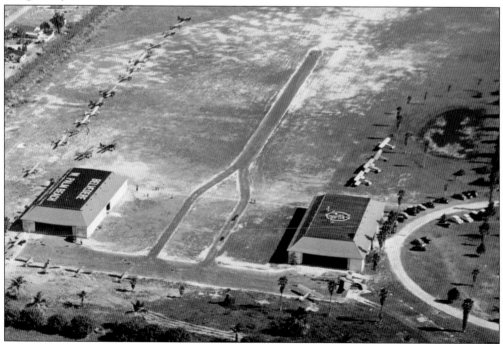

A mid-1930s aerial view shows Belvedere Airport, which was popular for sports aircraft. Occasionally small airplane races and shows were held here, many times prior to the big shows in Miami. The small dots on the hangar on the right are people painting the roof.

Grace Morrison moved from Atlanta to Palm Beach, and from 1926 to 1936, she worked as secretary for local architect Maurice Fatio. Grace was one of the first local women interested in aviation and took flying lessons at Belvedere Field, where she made her solo flight in 1932. Afterward Grace joined the Palm Beach County Airport Association and became its president. She led the way in getting a modern airport built in Palm Beach County. Before the airport officially opened, she was killed in a traffic accident near Titusville in September 1936. When the airport was dedicated on December 19, 1936, it was named Morrison Field in her honor.

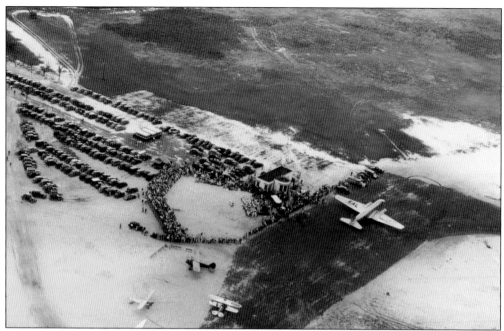

On December 19, 1936, dedication ceremonies were held at Morrison Field. Officials and spectators gathered to see the dedication and the first Eastern Airlines flight land and take off. The airport cost almost $180,000 and covered 440 acres with three 3,000-foot runways and a new administration building used for the airlines passenger terminal and government weather equipment. Maurice Fatio donated 200 trees for beautification of the airport.

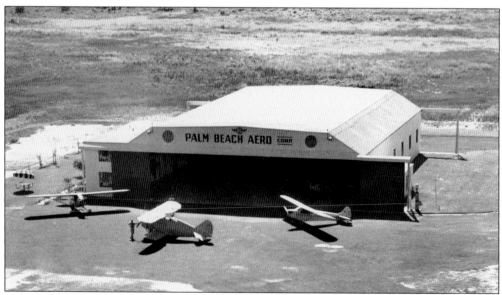

When Morrison Field opened, there were no fixed-base operations for aircraft. In January 1937, the Palm Beach Aero Corporation formed and signed a five-year lease with the county to provide operations at the airport. Within a few months, the company built a hangar and began providing services such as sales, storage, aircraft maintenance, parts and equipment, student training, and charter services.

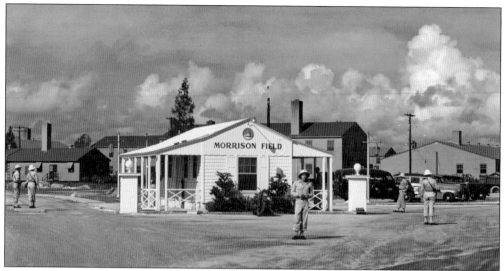

In 1940, the U.S. War Department approved the stationing of Army Air Corps units at Morrison Field. Subsequently, the air corps took control of the airport and established the Air Transport Command. During the war, more than 3,000 GIs were stationed at Morrison Field and more than 6,000 military aircraft passed through with men and supplies to North Africa and over the Himalayas, dubbed the "hump" by pilots.

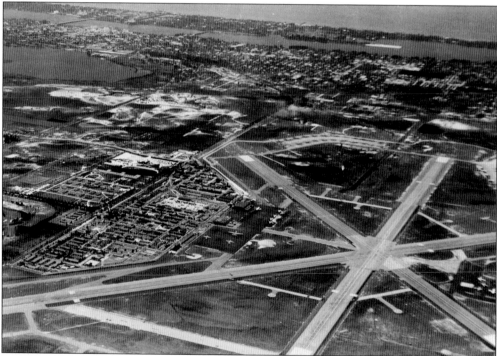

An aerial view of Morrison Field is pictured toward the end of the war. To the left of the runways are the barracks, hangers, and operations buildings. Belvedere Road is visible, and across the road from the airfield is the military housing area for families. In the upper-left corner is Clear Lake and West Palm Beach. Lake Worth, Palm Beach, and the Atlantic Ocean are at the top of the photograph.

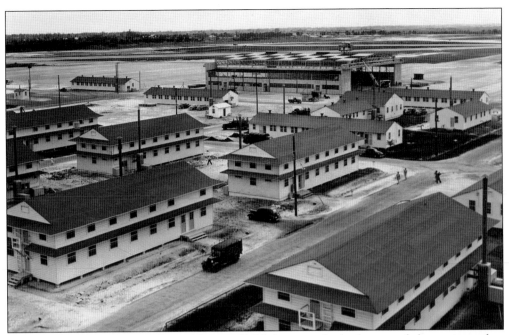

When the Army Air Corps took over Morrison Field, the airport had to be expanded to accommodate military operations and personnel. Pictured are barracks, operations buildings, and a hanger on the north side of the airport along Belvedere Road in about 1941. Military family housing was also built for married service members.

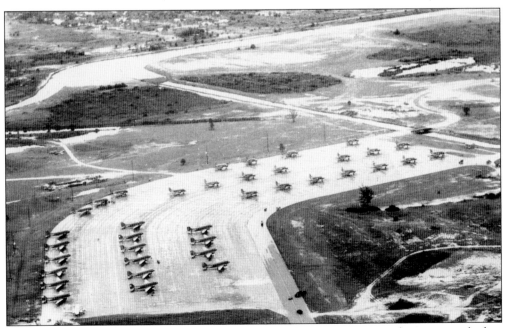

At Morrison Field, Army Air Corps Douglas C-47 Skytrain transport planes are parked in formation on the apron during World War II. These twin-engine aircraft had a maximum speed of 224 miles per hour and a maximum range of 1,600 miles. They were used to transport men and supplies to North Africa and to the Allies fighting the Japanese in China.

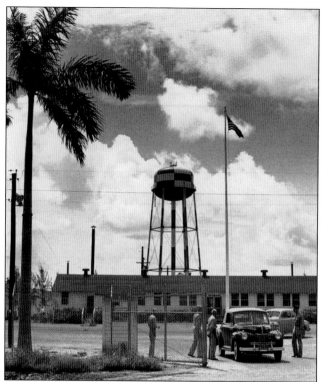

An entrance to Morrison Field off Belvedere Road had armed guards or military police who were stationed at the gate 24 hours a day and checked the identifications of all personnel entering the installation. The long building conveniently located behind the gate is the post headquarters, where the commander of the installation was located.

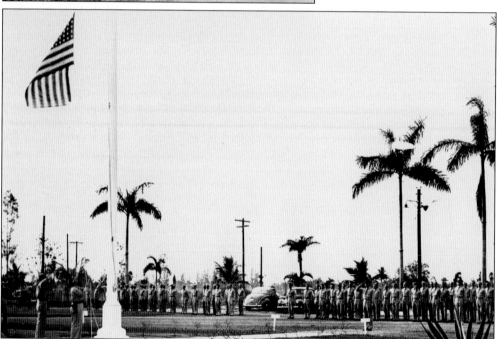

Flag call was held at Morrison Field's main flagpole near Belvedere Road during World War II. Morning flag call, reveille, was held every morning to raise the flag, and retreat was held at the end of the day to lower the flag. Most times only a small detail was needed to raise or lower the flag. However, some troop formations were held at the flagpole.

116

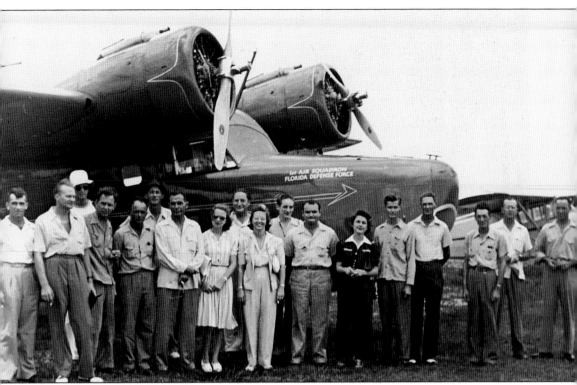

After Florida's National Guard was called into active duty by the federal government, the state legislature passed the Florida Defense Act in April 1941. Under the act, a "home guard" of volunteers was formed to fill the void left by the National Guard. The Florida Defense Force, under the command of the governor, included infantry and air units throughout the state that could respond to state emergencies. In May 1941, the air arm of the Florida Defense Force, the First Air Squadron, which enlisted men and women, was mustered into service at Morrison Field. Local aviator and president of Palm Beach Aero Corporation Wright Vermilya Jr. commanded the unit. Local businessmen and county officials such as Marshall E. Rinker Sr. and county commissioners John Prince and Cecil Cornelius joined the unit. Some of the members are pictured in front of a Sikorsky amphibian. Vermilya is seventh from the left, and county commissioner Cecil Cornelius is second from the right.

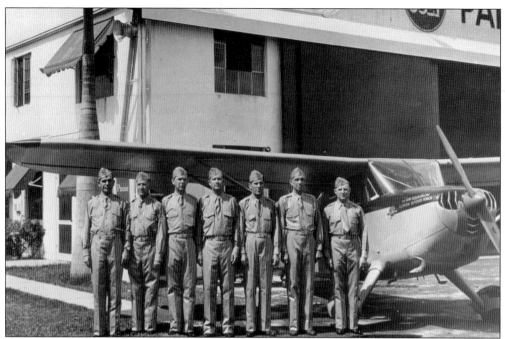

A group of pilots of the First Air Squadron poses for this photograph next to one of their planes, a Stinson Voyager, in front of the Palm Beach Aero Corporation. Vermilya used his hanger as the squadron headquarters. He is at far left. Fourth from the left is Art Keil, city publicist for West Palm Beach, and at far right is Jake Boyd, county engineer.

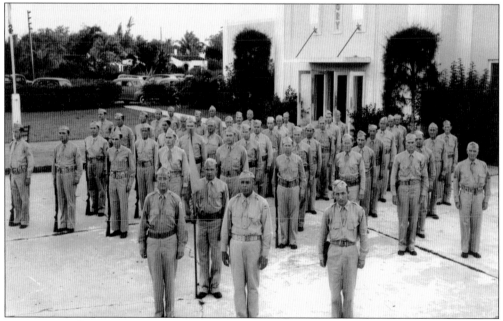

Company E, 7th Battalion, the local infantry unit of the Florida Defense Force, stands in formation at the National Guard Armory in West Palm Beach. Capt. Richard D. Hill, who is standing at the left front, commanded the unit. He worked for Florida Power and Light for many years. The unit, consisting of 62 volunteers, was mustered into state service in July 1941.

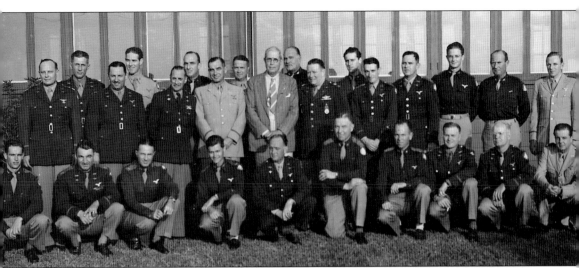

A national Civil Air Patrol (CAP) was formed December 1, 1941, by executive order to free military aviators of routine tasks on the home front. Wright Vermilya was appointed as the commander of the new Florida CAP Wing. In March 1942, the CAP established Coastal Patrol Base Three at Morrison Field to fly anti-submarine patrols along Florida's east coast searching for German U-boats attacking Allied shipping. Members of Coastal Patrol 3 at Morrison Field, c. 1943, are, from left to right (first row) Flight Officer A. G. Thompson; Capt. J. L. Gresham, base commander, Flagler Beach; Lt. E. V. Quinn; Wesley B. Jackson; Lt. Thomas C. Manning; Flight Officer J. F. Reeve; Lt. George E. Kent; Lt. Carl Dahlberg; Lt. Bert Krueger; and Lt. E. H. Gates; (second row) Capt. R. P. Robbins; Lt. Kris Granning; Capt. Theodore Hardeen; Lt. Wallace King; Lt. Col. Ray T. Middleton, executive officer; Lt. Charles A. Van Wormer; Maj. Wright Vermilya Jr.; Lt. James A. Sapp; Brig. Gen. Earnest D. Scott (retired); Lt. Gurnee Munn; Col. Vincent Melroy, commanding officer, Caribbean Wing, Morrison Field; Lt. A. D. Thomson; Lt. Arthur Sprott; Capt. Art Keil; Lt. Hood Bassett; Flight Officer Walter Carey; and Lt. Wiley Reynolds Jr.

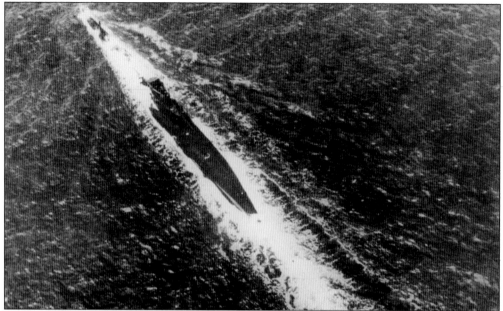

A CAP anti-submarine patrol took this photograph of a German U-boat in 1942. Following the Japanese attack at Pearl Harbor, the Germans launched *Paukenschlag* (Operation Drumbeat), attacking the shipping lanes along the U.S. East Coast. The war arrived in Florida waters in February 1942 when German U-boats began attacking Allied shipping off both the Atlantic and Gulf Coasts.

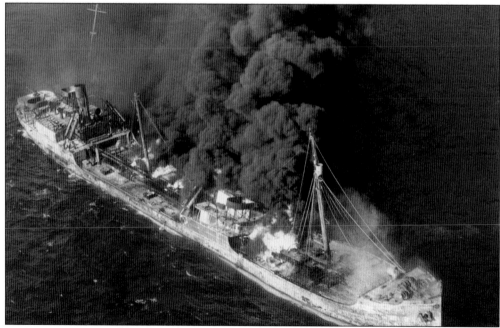

One of many victims of German U-boat attacks burns in the Atlantic Ocean off the Florida coast. In 1942, sixteen ships were damaged or sunk between Palm Beach County and Melbourne. It took effective cooperation between the U.S. Army Air Corps, Navy, Coast Guard, and the Civil Air Patrol to defeat and drive off the U-boats from the East Coast by 1943.

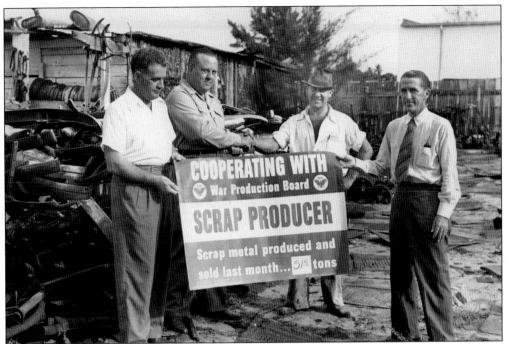

Civilians collected scrap metal used to manufacture war supplies such as small arms, tanks, and planes. In 1942, the Scrap Producer Merit Award was awarded to Gagon Auto Parts, the first award in the county to be given in recognition for cooperation in the National Salvage Program. From left to right are Marvin Mounts, West Palm Beach mayor J. O. Bowen, A. F. Gagon, and auto salvage inspector C. M. King.

A troop formation is pictured in front of the fountain at the Breakers Hotel. The renowned Palm Beach hotel was converted to Ream General Hospital in 1942. The hospital was also for the families of military personnel. During the war, several babies were born at the hospital. Toward the end of the war, it was returned to civilian control and reopened as soon as the hotel was refurbished for guests.

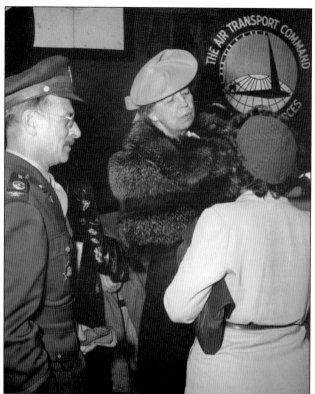

During a visit to military bases in March 1944, First Lady Eleanor Roosevelt stopped in Palm Beach to inspect Ream General Hospital. She landed at Morrison Field and spent the night in Palm Beach. During her stay, the First Lady also visited the Volunteers for Victory, or V for V, Soldier Canteen.

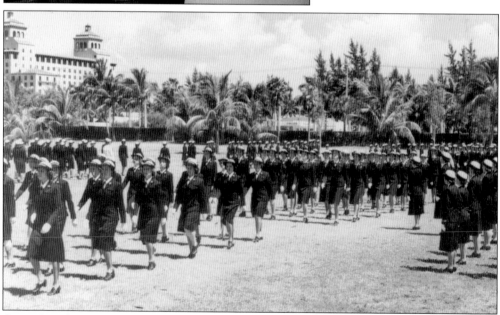

Coast Guard SPARs, which was formed in 1942, are on parade south of the Biltmore Hotel in Palm Beach. In 1943, the Coast Guard leased the Biltmore to use as a SPAR training center. In 18 months, about 7,000 women trained there. The word SPAR is a contraction of the Coast Guard's motto—*Semper Paratus*, Always Ready—and is also a nautical term for a mast or yard on a ship.

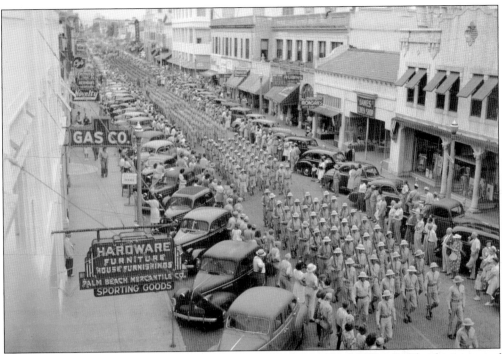

A military parade marches east on Clematis Street during World War II. The formation of servicemen stretches into the distance past Burdines and the Comeau Building. Local military units from the U.S. Army, Navy, Coast Guard, and the Florida Defense Force participated in national holiday celebrations such as Fourth of July or for specific military ceremonies.

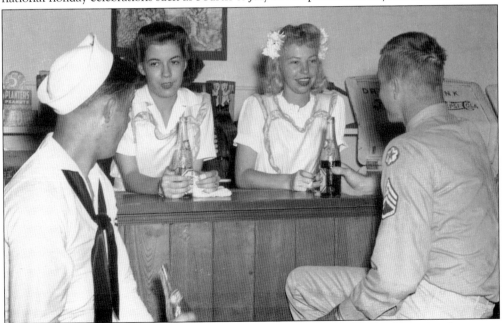

A sailor and a soldier take a break to have a soda and chat with waitresses in a local canteen. During the war, an inexpensive place to eat was the Hut, a favorite burger joint on Phillips Point where the average check was about 40¢.

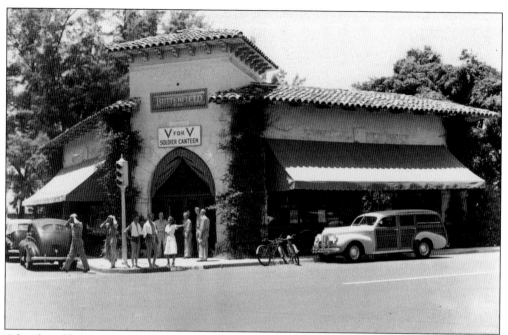

A local establishment set up to entertain troops in the Palm Beaches was the Volunteers for Victory Soldier Canteen at 416 South County Road in Palm Beach. In one six-month period, the canteen served over 42,000 sandwiches to hungry GIs. The V for V also operated a bathhouse on the beach. Before the building became a canteen, it was the J. H. Butterfield Company grocery store.

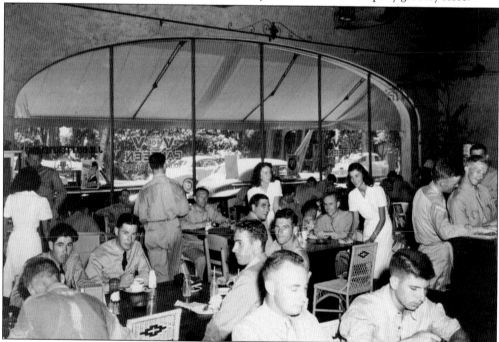

This is the interior of the V for V Canteen, where soldiers and sailors could get a meal, something to drink, and smiles from the waitresses. Servicemen and women were able to relax and read a book or the newspaper in the canteen's reading room.

Another entertainment facility in downtown West Palm Beach providing services to GIs was the Servicemen's Center at Olive Avenue and 2nd Street. In a reading room, soldiers from the air base mingle with Coast Guard SPARs from Palm Beach.

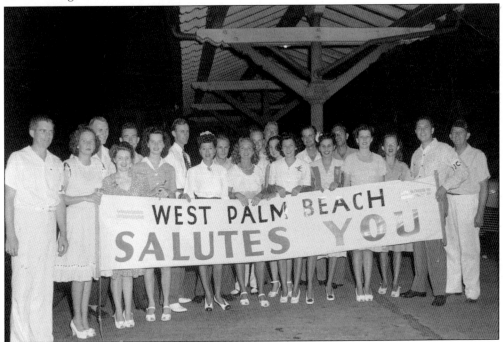

A welcoming committee gathered at the Seaboard Air Line train station at Tamarind Avenue and Banyan Boulevard to greet troops returning from the war in August 1945.

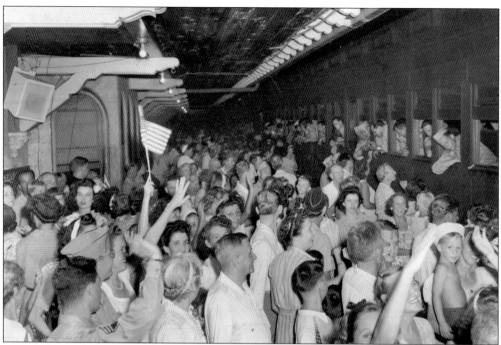

In 1945, at the Seaboard Air Line train station, family, friends, well-wishers, veterans, and servicemen welcome troops returning from the war in Europe.

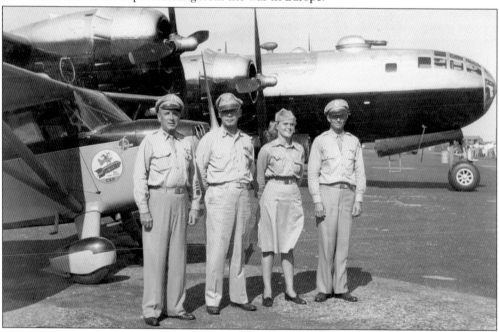

The Army Air Force and the local Civil Air Patrol are pictured here at Morrison Field on August 1, 1945, for Air Force Day. From left to right are Capt. Ralph Cohn, CAP pilot; Captain Clark, Army Air Corps, pilot of the B-29; Cadet Butler, CAP cadet; and Lt. Tom Smith, CAP pilot. A B-29 bomber is in the background, and the smaller plane is a Stinson Voyager used by the CAP. (Courtesy Jill Mosley.)

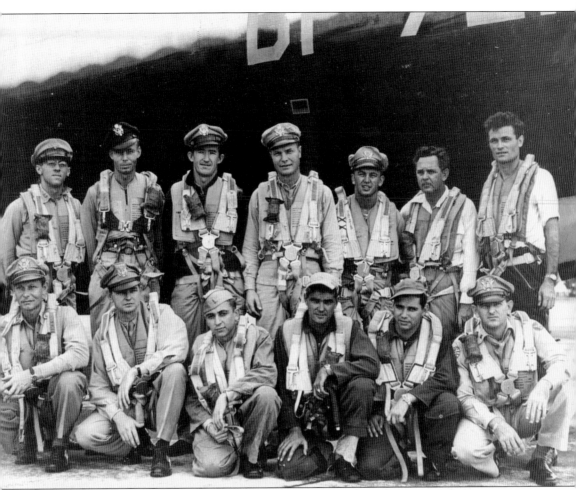

The crew of a reconnaissance plane from the 55th Squadron undergoing training by 1st Air Weather Group at Morrison Field flew over a tropical hurricane on October 7, 1946. This was the first time a B-29 had ever flown over a hurricane. The crew of the B-29 Hurricane Observation Flight are, from left to right, (first row) 1Lt. Richard W. Comer, public relations officer; Capt. Arnold A. McCarley, weather observer; 2Lt. Jack Williams, army photographer; TSgt. L. R. Campbell; T/Sgt. Jack C. Ray, radio operator; and 1Lt. W. D. Kelly, scanner; (second row): Capt. Alvin K. Funderborg, radio operator; Capt. Homer E. Brown, navigator; Lt. Col. William B. Tyer, pilot; Maj. Paul H. Fackler, pilot; 1Lt. John Andrew, engineer; Art Keil, United Press civilian photographer; and John J. Horton, United Press civilian photographer.

www.arcadiapublishing.com

Discover books about the town where you grew up, the cities where your friends and families live, the town where your parents met, or even that retirement spot you've been dreaming about. Our Web site provides history lovers with exclusive deals, advanced notification about new titles, e-mail alerts of author events, and much more.

Arcadia Publishing, the leading local history publisher in the United States, is committed to making history accessible and meaningful through publishing books that celebrate and preserve the heritage of America's people and places. Consistent with our mission to preserve history on a local level, this book was printed in South Carolina on American-made paper and manufactured entirely in the United States.

This book carries the accredited Forest Stewardship Council (FSC) label and is printed on 100 percent FSC-certified paper. Products carrying the FSC label are independently certified to assure consumers that they come from forests that are managed to meet the social, economic, and ecological needs of present and future generations.

FSC
Mixed Sources
Product group from well-managed
forests and other controlled sources

Cert no. SW-COC-001530
www.fsc.org
© 1996 Forest Stewardship Council

Find Your Place in History.